ANTIPODES
Inside the White Cube

curated by Louise Neri

Index

Inside the White Cube is a project in
cooperation with Dornbracht Culture Projects.
www.cultureprojects.com

ANTIPODES
Inside the White Cube

First edition 2003 published by White Cube

Editor: Louise Neri
Editorial coordination: Honey Luard and Sophie Greig
Art direction: Louise Neri with Mike Meire and Florian Lambl
at NEO NOTO, Cologne

Essays © The authors 2003
Artworks © The artists

Lithography by PPP, Cologne
Printed in Germany by Meinders + Elstermann GmbH & Co. KG

ISBN 0-9542363-8-6

WHITE CUBE
48 Hoxton Square
London N1 6PB
Tel. + 44 (0) 20 7930 5373
Fax. + 44 (0) 20 7749 7480
www.whitecube.com

Having opened the cover of this book, designed to mimic the sober no-frills style of conceptual art publications from an earlier time, you will have flipped through several different coloured versions of a map fragment to get to this page. The original map, from which the fragment was taken, was made by an anonymous European cartographer in the sixteenth or seventeenth century to depict a world as yet only partly explored. The mysterious, variously textured map is scattered, inexplicably, with Chinese-looking characters; a vast land mass covers the southern pole and extends up toward the known continents and their archipelagos. This un-named zone was known as "the Antipodes", an ancient Greek term coined by the first cartographers, which described the *terrain vague* of an opposite hemisphere and fuelled centuries of rabid yet fertile cultural superstition about an imagined place where men walked around upside-down, completely contrary to nature.

Living in a time where such literal notions, at least, have been dispelled by our empirical knowledge of the world, I decided to use "antipodes" as a geographical metaphor for the extraterritorial condition of the contemporary artist who is fixed within a particular spatial group yet whose position relative to this group is determined, essentially, by the fact that not having "belonged" to it from the outset, s/he is able to import foreign qualities into it and thus provoke positive confrontation. "The artist" writes George Steiner, "dreams against the world as we know it", creating structures that are *otherwise*.[1]

My inquiry, then, is conducted with a spatial picture rather than a theory. By the end of the book, which attempts to capture the essences of an exhibition programme in dramaturgical and conceptual, rather than chronological and empirical form, the map is turned upside-down so that the imagined artistic hemisphere now looms over the diagram of the real world.

First published in *Artforum* in 1976, Brian O'Doherty's legendary essays on the ideology of the gallery space were subsequently collected in an anthology entitled *Inside the White Cube*. In these essays, O'Doherty revealed the assumptions on which modern commercial and museum gallery spaces were based, suggesting a rethinking of the fate of art entering the twin spheres of aesthetics and commerce. Bringing into focus the sixties and seventies exposure of the system through which art must pass in our culture, from physical intervention in the gallery space to institutional critique, O'Doherty raised the issue of how all artists must construe their work in relation to that space and system.

The economic boom in the eighties saw parallel developments of widespread critical investigation of the relation between the burgeoning art market and the context of presentation; in the nineties, this was succeeded by more subtle and collaborative interventions which provoked new uncertainty about the division between art and reality, as artists drew freely from a wide range of themes and sources in popular culture, utilizing the gallery space for situations of potential interaction rather than of forced confrontation or imposed participation.

Thus the investigation has run its course, and the advantages of the white cube, as a "neutral" background or "abstract" framework for diverse artistic questions and explorations, are now appreciated by artists, curators and the public alike. By trademarking the name "White Cube" for his own gallery enterprise in the early nineties, Jay Jopling created a charged site for artistic interaction and exchange in the newly burgeoning British art scene. Over ten years, this small project space in central London became a hub for many local and international artists in a programme of wide-ranging and sustained vitality, with an influence far exceeding its modest physical dimensions. When it closed its doors late in 2002, Inside the White Cube opened on cue, a version of the original space in White Cube's larger east London premises, but with a brief that proposed a guest curator working in counterpoint to the host programme.

Jay and his director Annushka Shani approached me to be the inaugural curator, following the American photography exhibition that we had made together the previous year while I was still living in New York City. In our intensive discussions for this new venture, Jay, Annushka and I imagined many different possible scenarios for the space, including the rather extreme idea of conceiving and staging exhibitions and experiences for one viewer at a time. But, finally, rather than us determining the operative situation so strictly in advance, it was the artists who would articulate the eventual breadth of relationships between object, space and viewer, including several that actually played out the one-to-one experiences of our imagination.

Significantly, the preparatory period for Inside the White Cube marked my period of transition from America to Europe, a second phase of uprooting that followed my move from Australia to America more than a decade before. During the twelve years that I lived in New York City in the same apartment on Washington Square, the only work of art that inhabited my front room was one that was hardly ever noticed. It disappeared in a certain light; visitors sat with their backs to it, or secretly wondered why I didn't put something on the wall to cover the grimy trace where something evidently once was.

"Where something once was" is, in fact, a drawing made by David Hammons, a fragile that remains indelibly etched on the wall, and in my memory, of an artist, a gift, and a place called home in a city where I no longer live.

I remember David getting up from his chair, taking a sheet of copy paper and sticking it to the wall. Passing the palms of his hands quickly over the soles of his shoes to pick up some of the grime accumulated there from many hours spent wandering the streets of New York, he then rubbed them vigorously over the patch of wall where he had stuck the paper. When he removed the paper from the wall, a sharp edge inside the smudge appeared. Taking a small nail, he made a hole below the upper edge of the impression, and the drawing was finished.

After this deft poetic act, immaterial yet deeply generous, and authorial by virtue of its anonymity, it was impossible for me ever to put anything else on the walls of that room. And, over the years, the presence of that work's absence expanded to fill the place in which I lived — a metaphor, perhaps for my own experience of being perpetually "unhoused", as Steiner describes the state of "not being thoroughly at home in the language of one's production, but displaced or hesitant at the frontier".[2]

When I moved out of that apartment last year to another city and another continent, the drawing, of course, remained, revealing its full significance in the evacuated interior. I still think about that drawing a lot, keeping company with the ghosts of other things that were once there, and some dust breeding.

Hammons agreed to inaugurate Inside the White Cube with a rather classical installation of a single sculpture and a monumental framed drawing. But then, just a few days before the opening, as if in complicit acknowledgment of my transition, he added a surprise element. Giving me his personal drawing tool, an American basketball impregnated with New York City grime, he asked me to take it to London and make a drawing. We did some practice shots in his studio. When I asked him to instruct me further as to how to "play" the space itself when I got to London, he answered softly, "With a light touch".

Louise Neri

Endnotes:
[1] George Steiner, *Extraterritorial: Papers on Literature and the Language Revolution* (New York: Atheneum, 1968), 34
[2] Ibid, 3

7

DAVID HAMMONS

Concrete Poetry

In recent years, David Hammons' work has evolved beyond the poignant and sardonic observations on black culture and life for which he is known to embrace a level of abstraction that invokes his fascination with symbolic orders in art and life. In works such as *Global Fax Festival* (2000) and *Holy Bible: The Old Testament* (2002), reference to "black culture" does not disappear but, by dint of the fact that these works have been made by Hammons, "black culture" becomes an implicit rather than explicit factor.[1] Ultimately they challenge the very idea of cultural specificity within Hammons' art.

In *Global Fax Festival*, nine fax machines were suspended high overhead in the Palacio Cristal, an opulent glass pavilion in Madrid's Parque del Retiro. For the summer-long duration of the installation, faxes, sent randomly from the local and international public, spewed forth and floated down gracefully to litter the floor of the pavilion. As with much of Hammons's oeuvre, *Global Fax Festival* resonates with the tension of opposites: in this case, Hammons played the order of the iron and glass architecture against the lyrical chaos of the faxes, the technological advances of the Industrial Age against those of digital technology. In *Holy Bible: The Old Testament*, he appropriated and combined two epic tomes — the Bible and Arturo Schwarz's catalogue raisonné of Marcel Duchamp.[2] Rebinding the catalogue raisonné in the form of a huge bible, replete with gilt-edging, gold-tooled lettering and black goatskin cover, Hammons plays havoc with received value systems, paying homage to Duchamp's readymade while critiquing the idea of conceptual art as a kind of religion, with Duchamp as its high priest. And, in appropriating Duchamp, Hammons critiques himself as a latter-day disciple of the readymade.

These recent works are quite distinct from earlier works, not only in their subject matter, but also in Hammons' choice of materials. Absent is his trademark use of the detritus of everyday urban living- the bottle tops, chicken bones and wine bottles; the thrift shop and flea market acquisitions. However, what is common to both is his evident fascination with symbolic orders that spans the spiritual significance of hair in shamanistic ritual, to the sacred cows of contemporary art, to the cultural significance of the latest Nike Air Max™ running shoes.

In his exhibition at Inside the White Cube, with a single sculpture, *Rock Head* (2000) and a large, framed drawing, *Travelling* (2002), Hammons refigured some of his signature motifs — rock, basketball, dirt, and hair — that he has made synonymous with a certain idea of black culture. With his distinctive take on the readymade, Hammons converts these motifs into the signs of a specifically black, male, urban, working-class experience. In a series of monotypes from the early seventies that he made by pressing his greased clothes, skin and hair onto paper, and then dusting over the greasy imprint with pigment, Hammons reduced the physical body to a sign. With titles like *Spade* and *Pray for America*, the allusion to stereotype was unequivocal at a time when the prevailing status quo

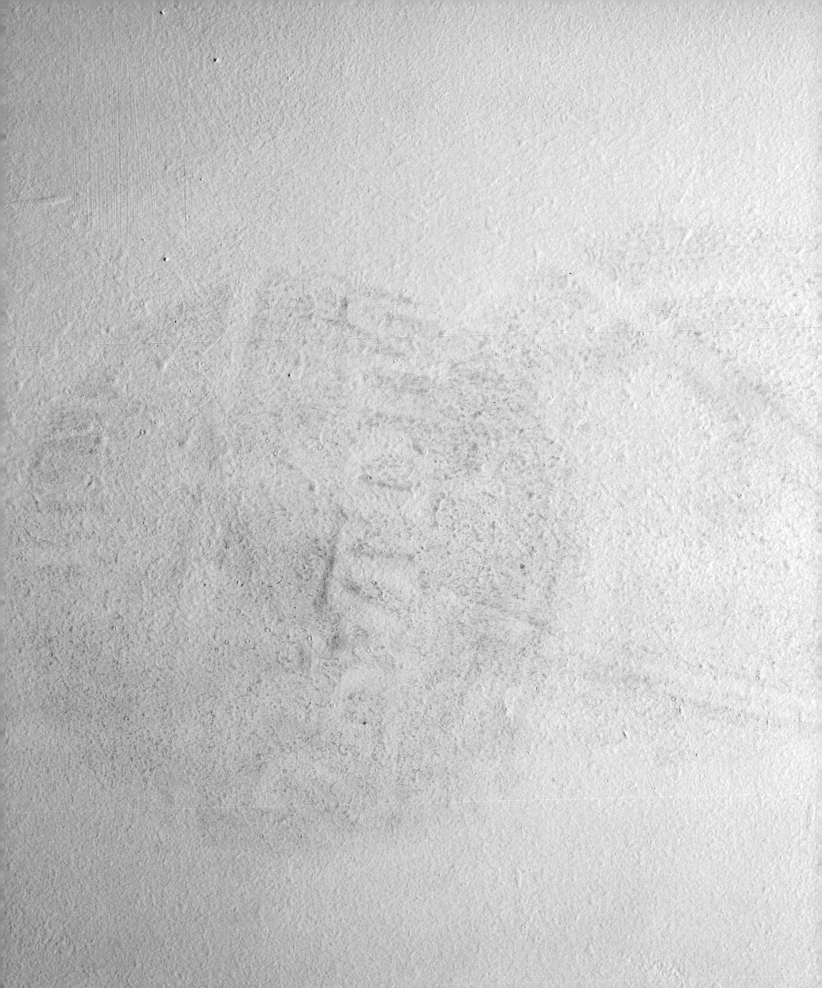

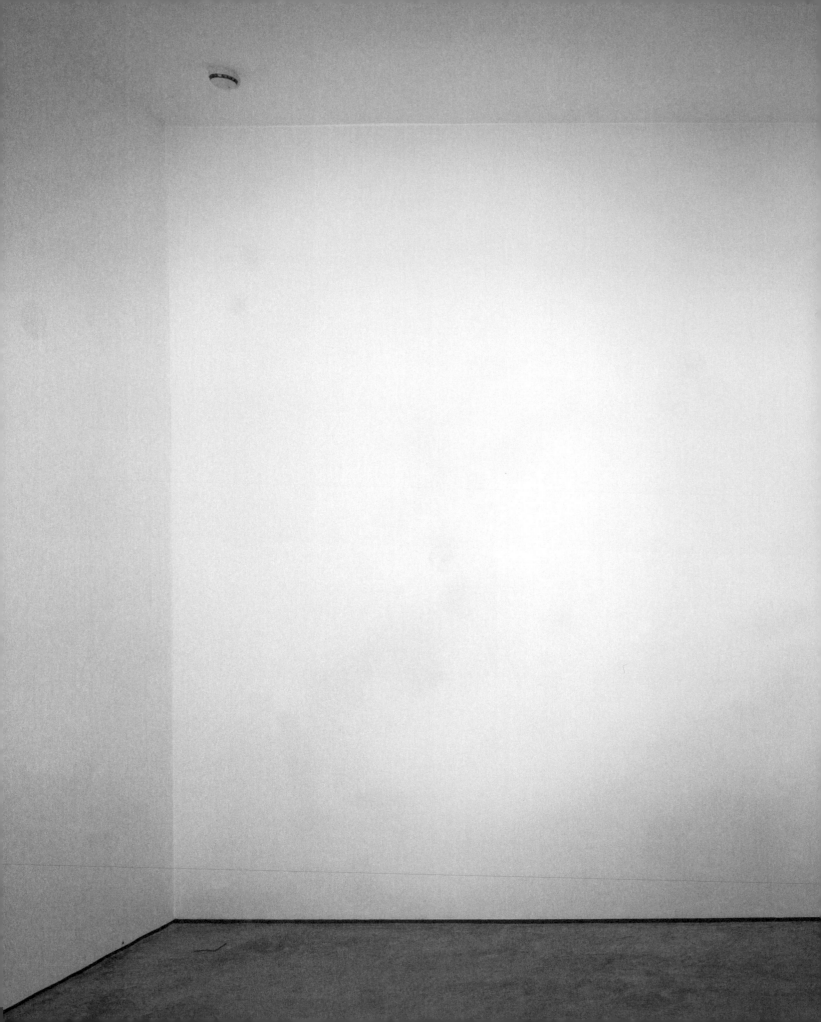

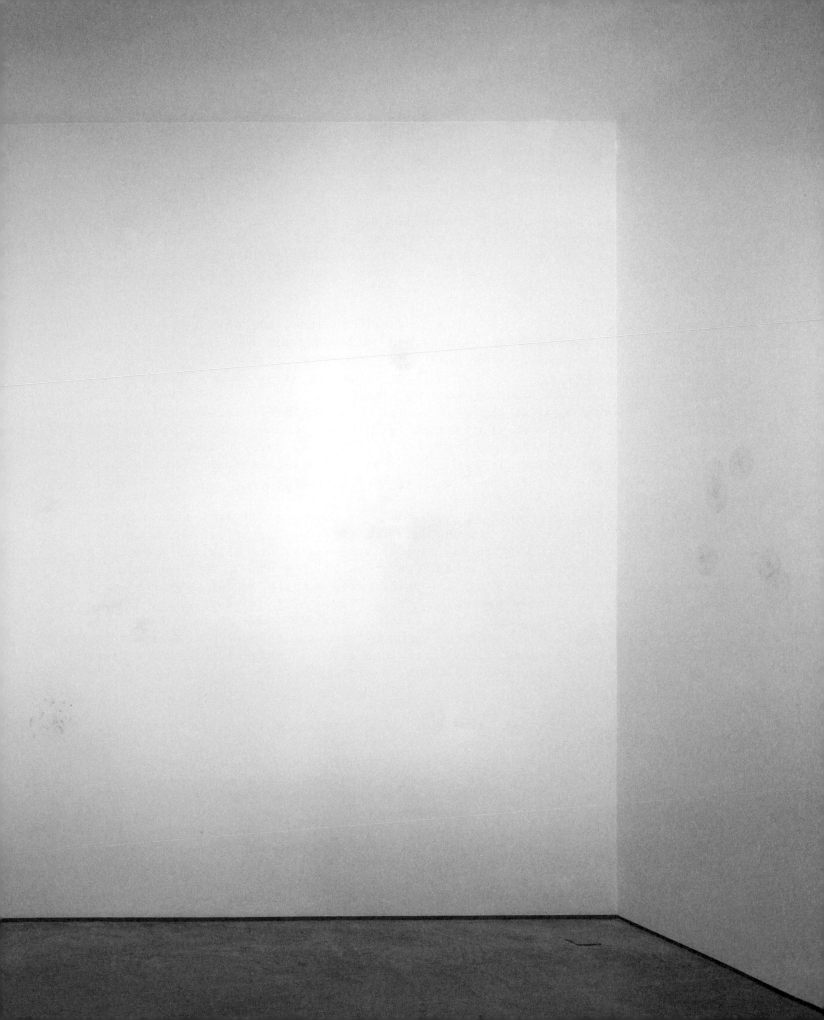

in America was being vehemently contested in a climate of intense political activism with regard to the Vietnam War, black civil rights, and women's liberation. With *Higher Goals* (1982), a basketball hoop erected on top of a fifty-five foot telegraph pole in Harlem became a poignant symbol of unattainable ambition amongst black American youth.

These earlier narratives were embedded in the fabric of the current exhibition and had a curious effect on one's viewing of the work. It was like being in an echo chamber, the two works resonating with traces of earlier mythic works, so that the space itself became an axis between past and present, presence and absence, truth and mimicry.

Rock Head is a slightly larger than human-sized stone, adorned with afro hair, culled from the sweepings of of a Harlem barbershop and applied to mimic the latest razor-cut styles. *Rock Head* sits elegantly in a vitrine set on an appropriately black plinth, "facing" *Travelling*, a tall, framed drawing. The nebulous marks of the drawing are the "index" of a dirty basketball being repeatedly bounced against the paper. Just clearing the floor, the bottom edge of the drawing sticks out from the wall; a cheap cardboard suitcase has been wedged between it and the wall. A spray of imprints from a dirty basketball travels across the wall at irregular intervals, at once a trace of the artist's presence, a sign of "blackness," and a piece of Harlem.

Rosalind Krauss has described the index as, "the type of sign that arises as the physical manifestation of a cause, of which traces, imprints, and clues are examples."[3] Hammons' exhibition was rich in such signs. The index is proof of a specific action, an undeniable truth. The creation of an indexical sign involves reducing a conventional sign to its essence, for example, a wet footprint on a bathroom floor, or a dirty basketball imprint on a white gallery wall. Hammons uses the reductive function of indexicality to mimic that of the stereotype, which reduces a fully constituted person to a caricature. In articulating indexicality thus, Hammons allows for a critique of stereotype that spans terrain as seemingly disparate as black vernacular culture and the myth of the artist.

Rock Head's presence in the white cube space made for a tense dialogue between the idiosyncrasies of black vernacular culture and the sculptural traditions of Modernism. That said, Hammons is fairly even-handed with his targets: In 1992, he took a similar sculpture to a Harlem barbershop for a haircut, which was recorded on video. Of course, this act was absurd, as it would be in any other barbershop. What Haircut highlights is Hammons' active reflexivity, how he sets the notion of vernacular culture against itself and, in doing so, leaves himself open to the possible derision of the black community. Hammons' use of humour is barbed; it is as much a means of confronting social boundaries as transgressing them. He has remarked of similar acts," It's putting myself out there to be laughed at. Black people, we have more problems with being made fun of than any people I've met. That's why it's so important for us to be cool, cool, cool. If

you're not cool then you're something else and no one wants to be that other thing."[4] Hammons has the ability to skew the context of his own work, to make it strange even to itself. It can be as much at odds in a Harlem barbershop as in a white-walled gallery in London, yet, paradoxically, its potency is such that it can traverse two such distinct cultural territories yet remain pertinent to both.

Rock Head and *Travelling* are saturated in conflicting truths and myths about contemporary African-American culture. Arguably, the young, working-class, African-American male has long been a target of major sports companies and the music industry, whether as potential consumer or potential commodity.[5] Hammons exposes the flipside of this phenomenon, the stereotype of the black male as ever aspiring, naturally athletic, hopelessly style-conscious, and essentially poor. In turn, the indexical nature of the basketball imprint and the discarded hair clippings imbue them with a certain veracity, since these elements are indeed authentic by-products of the black neighbourhood of Harlem and, thus, signs of "blackness". What is perverse is that such specific signs of a specific locale can be so immediately readable on a global level. That they can be recognised on the streets of Accra, London, Tokyo or New York indicates the pervasiveness of stereotypes of black culture and, more specifically, how effectively they are propagated through the shrewd marketing and merchandising of major sports companies and the music industry.

But Hammons surely implicates himself in this narrative. The performative, indexical nature of *Travelling* recalls his early body prints, where he was "both the creator of the object and the object of meaning,"[6] and thus he is inseparable from the stereotype to which he refers. Hammons's willful conflation of subject and object has been described by David Joselit as the artist's "occupation of a stereotype"[7] and this idea of "occupation" is strongly evident in *Travelling*, where the role of the artist is like that of the basketball player, the skill of his draughtsmanship only ever equal to his dexterity with the ball.

Just as the razor-cut and the basketball in *Rock Head* and *Travelling* are visible signs of African-American culture, so too is Harlem. And, just as the razor-cut and the basketball are signs of social aspiration, so too is Harlem. From its original incarnation as a white, middle class district in the nineteenth century; to its resettlement by black workers from the South around the turn of the following century; to the artistic renaissance in the twenties; to the militance of the fifties and sixties, Harlem itself is subject to the same mythologizing that produces the signs of "black culture". It is the topic of countless cultural interpretations, each of which responds to and propagates Harlem's mythology — from Jean Bach's "A Great Day in Harlem "to the Harlem Globetrotters, Aretha Franklin's "Spanish Harlem" to Lil' Rowdy's "Harlem's Pearl", and U2's "Angel of Harlem" to Mase's "Harlem World". This mythology inscribes Harlem in the international collective consciousness as one of America's most enduring cultural exports.

But the mythology of Harlem surely relies on a perceived notion of its own authenticity with regard to its black communities, its cultural history, its sporting history, its poverty and so on. Hammons conjures Harlem in the gallery space via real Harlem barbershop waste and real Harlem dirt. Through such "evidence", he further embellishes the myth, for the Harlem that Hammons portrays is the same Harlem in the process of rapid gentrification, where Bill Clinton has recently bought property, where Starbucks has taken root and which is being hailed in mainstream journalism as the "next SoHo".[8] The irony of the current situation, that Harlem may be returning to its white, middle-class roots, is not lost on Hammons, who has commented with his usual caustic wit: "Harlem is under attack. White folks want it back."[9] Yet in his art, he is very selective in his choice of imagery: he gives us a myth of Harlem because that is what we want. Paul Gilroy observes that "Authenticity enhances the appeal of selected cultural commodities,"[10] even if, in this case, such "authenticity" is a mirage and the commodity is a work of art. In his usual levelling manner, Hammons shows the human desire for authenticity — in works of art, sportswear or real estate — to be as potent as ever.

Virginia Nimarkoh

Endnotes:
[1] Preempting the making of such "implicit" works, Hammons said, "I am going to make stuff with these new materials that doesn't necessarily have to do with my culture. But it will anyway, just because I made it." Interview with Robert Sill, "After Words," *David Hammons in the Hood* (Illinois: Illinois State Museum, 1993), 56
[2] Published by Delano Greenidge Editions, New York, 2000.
[3] Rosalind E. Krauss, "Notes on the Index: Part 2," *The Originality of the Avant Garde and Other Modernist Myths* (Massachusetts: MIT Press, 1986), 211
[4] Interview with Kellie Jones, reproduced in *Discourses: Conversations in Postmodern Art and Culture*, eds. Russell Ferguson, William Olander, Marcia Tucker, and Karen Fuss (New York:MIT Press and The New Museum of Contemporary Art, 1990), 215
[5] Consider, for example, Nike's recent record-breaking $90 million sponsorship deal with basketball prodigy, LeBron James. According to James' agent, a line of LeBron James sports shoes would be manufactured before his first game as a professional player. See David Teather, "Sponsor passes £55m to school basketball star before his first game," *The Guardian*, May 24, 2003
[6] Mary Schmidt Campbell, *Tradition and Conflict: Image of a Turbulent Decade, 1963-73* (New York: The Studio Museum in Harlem) 61
[7] David Joselit, "Towards a Genealogy of Flatness," *Art History*, March 2000, 27
[8] Deborah Solomon, "The Downtowning of Harlem," *The New York Times Magazine*, August 19, 2001
[9] Ibid. Solomon
[10] Paul Gilroy, "Black Music and the Politics of Authenticity," *The Black Atlantic: Modernity and Double Consciousness* (London: Verso, 1993), 99

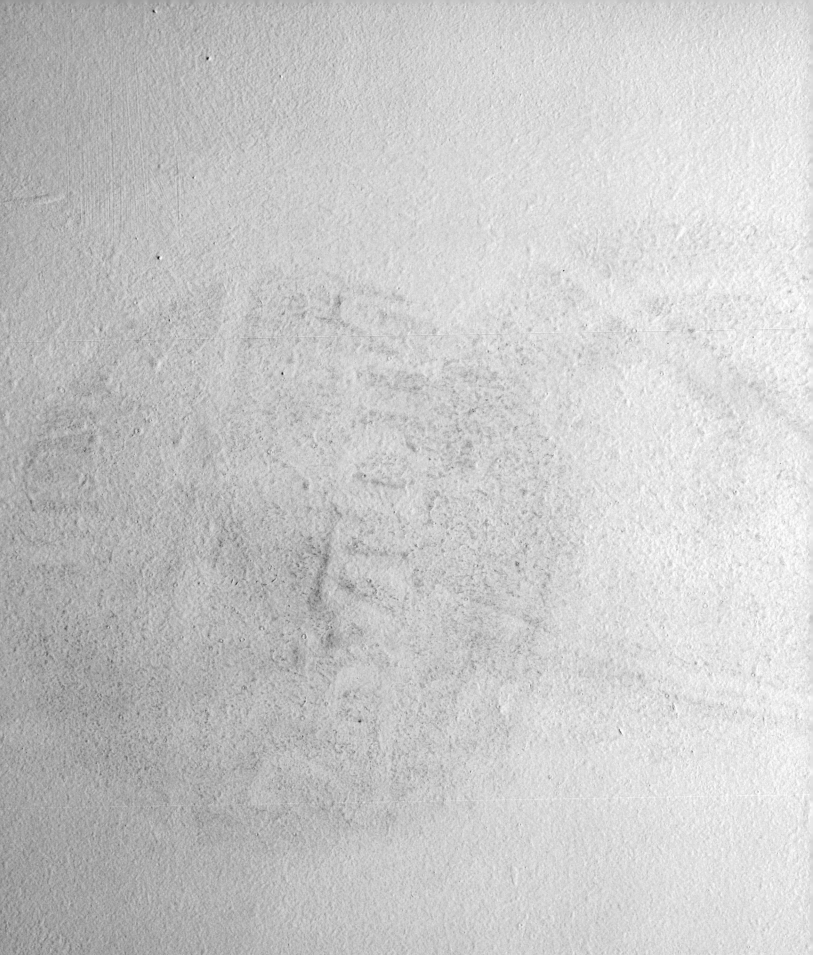

Neo-Classicism and Romanticism

Ingres
Géricault
David
Goya
Blake
Delacroix
Turner
Corot
Rousseau
Constable
Friedrich
Millet
Nazarenes

Beethoven

Courbet
Daumier

Frédéric Chopin

Richard

Painters

Haydn

Canova
Thorwaldsen
Rude
Daumier
Carpeau

Flaxman

Sculptors

Mozart

Robert Schumann

Boullée
Ledoux
Gilly
Labrouste
Pugin
Soane
Nash
Telford
Barry
Semper
Brunel
Viollet-le-Duc
Schinkel

Architects and Designers

Rossini

Paxton

Franz Schubert

CHRISTIAN MARCLAY

Notations

Fauvism
Rouault
Derain
Matisse

Post-Impressionism — *Erik Satie*
Seurat
Signac — *Charles Ives*
Surrealism
Miró
Dali
Cézanne
Ernst
Gauguin — *Harry Partch* — *Jimi Hendrix*
Van Gogh
Marées
Vuillard
Kelly Hard-Edge
Albers
Bonnard
Impressionism
Ensor
Munch
Cubism — *John Cage*
Picasso
Braque
Delaunay
Gris
Léger Duchamp
Monet — *Igor Stravinsky*
Renoir
Sisley — *Miles Davis*
Pissarro — *Arthur Honegger* — *Gordon Mumma*
Degas
Whistler — *Claude Debussy*
Suprematism
Malevich Tachism
Fautrier
Dubuffet
Boccioni — *Arnold Schönberg*
Severini
Carra
Art Nouveau — *Charlie Parker*
Klimt
Der Blaue Reiter
Kandinsky
Klee — *Morton Feldman*
Klimt — *Alban Berg*
Van Doesburg Abstract Expressionism
Mondrian
Pollock
De Kooning
Rothko
Davie
Tobey
— *Antonín Dvořák*
Pasmore
De Staël
Bacon

Brancusi
Rosso — *Karlheinz Stockhausen*
Maillol
González — *John Coltrane*
Epstein Caro
Degas
Duchamp-Villon Dalwood
Rodin
Renoir
Hildebrand
Matisse
Marini — *Iannis Xenakis*
Boccioni
Tatlin
Pevsner
Archipenko
— *Brahms* Arp
Gabo
Lipchitz
Moholy-Nagy — *David Tudor*
Moore
Calder
— *Gustav Mahler* Giacometti
Hepworth
Richter
César
Bill
— *Luigi Russolo* Paciozzi
Le Corbusier
Sullivan — *Philip Glass*
Loos
Maillart
Contamin — *Edgar Varèse*
Richardson Mendelsohn — *Pierre Henry*
Shaw Gaudi
Gropius
Van de Velde
Mies van der Rohe
Rietveld
Oud — *Pierre Schaeffer*
— *Tchaikovsky* Buckminster Fuller
Webb
Eiffel Wright
Morris Aalto
Niemeyer
Dutert Candela
Horta — *Ornette Coleman*
Voysey — *Christian Wolff*
Scott
Olbricht — *Moricio Kagel*
Mackintosh
Garnier Berlage
Guimard
Behrens
Poelzig
Perret
Sant'Elia
Saarinen

Performative Image, Inscribed, even: the fluid sound worlds of Christian Marclay

Phonography is doomed to invoke history at every level, yet simultaneously elevated by history from its material substance to a dizzying mythology shared by even the most casual user of the technology. In a Christian Marclay performance, records are slapped down onto turntables without ceremony, liquorice pancakes flipped onto the mould at production line speed. A rack of records stands by Marclay's two industrial strength decks and I recall my elder sister's late 1950s record rack, close enough to a wire toast rack in its design to conflate and confuse the rectangular perfumed seduction of burnt bread and the circular mystery of the platter.

Burning wax leads to melting, as any owner of vinyl left out in the hot sun can testify. Records have been platters, wax and numbers, 45 and 33 1/3 rpm waxings plunging us into an arcane science, a delirium of metaphors. In Marclay's hands, the wax melts, leaving a residue that can be visual, metaphorical, symbolic or sonic. Analogue history is a diverse and haphazard store of associations. In the wire toast rack on the stage sits a record on the Vocalion label. I think of jazz and blues records in my own collection, the distinctive Vocalion logo, a strand of American musical heritage through which the label names themselves carried traces of the mythology of recording (Vocalion descended from Aeolian). Coloured vinyl stands to attention, dishes in the drying rack, each waiting its turn to turn as Marclay works through his set. The colour of vinyl adds a sidebar to collecting, the candy-coloured (as Roy Orbison might have said) disc sought for its sense of bizarre juxtaposition: my translucent green Korean discs of Confucian music, Chinese language instruction 45s pressed on blue flexible vinyl; or Marclay's own *Record Without a Cover*, re-pressed on white vinyl. To re-press may repress previous faults, but coloured vinyl pressings can be more noisy than their black counterparts, so *Record Without a Cover*, a record whose intent is to deteriorate under the stress of being treated without proper care, hits the ground running.

Marclay lifts records from the turntable, stylus still embedded in the groove, dragging slurred timestretch bombs from the spiral scratch. This gouging, scoring action of the needle adds a spectre of pain to the process of playing a record, linking phonography to dentistry, carving inscriptions onto gravestones, vaccination, the art of tattooing, acupuncture, piercings, heroin, murder, the disgruntled bird whose beak is forced to function as stylus in *The Flintstones*, dipped against its will onto stone platters of caveman rock and roll that rotate on the shell of a turtle.

Etching is a close relative; inscription with a needle, acid-bathed, then pressed, or vice versa. Inscription and juxtaposition are two of the keys to Marclay's work. In his wonderfully prescient book, *The Recording Angel*, Evan Eisenberg wrote in 1987 of the cool mode he identifies in recorded music. "It can be seen as emerging from several of the paradoxes of phonography. To the abstraction of the audience it responds by speaking as if to a single, utterly

known individual, in the manner of a disembodied voice. To the reification of music it responds by creating a curious object. To the hardening of musical language it responds by juxtaposing phrases rather than using them; in place of rhetoric there is irony. (The same irony protects the phonographer from the irony of his unseen listeners, against which he would be defenceless — like the blind musician of folklore, whose descendent he is.)"

Marclay freely admits that his collages began as things to do when he was bored. "I never thought about them as finished works of art," he says. This sense of free play permeates his work, in which the open informality of musical improvisation closely links with the way in which modes can be flipped, meanings can be transformed and materials transmuted. Similarly, his photographs document a series of moments on the very edge of significance, incidents that only the most alert mind will register and frame. Here is an improviser's appreciation of the fragile instant; a quickness of eye that approximates the quickness of ear that can detect undercurrents, implications and concrete reference in musical flow.

Phonography and photography are almost identical words; in the grain of one is the inscribed memory of the other. A photograph is a record, ghosting a physical presence onto plastic, replaying memories like a score. The needle is also a form of pen, guided into hidden inscriptions beneath the surface of its black parchment. Record player design encapsulates the idea of self-destruction in perpetuity. The needle ploughs through the spiralled groove, wearing away both itself and the music it transmits. Each performance writes its own slow suicide note. Decay follows death as an inscription on the body. "A drawing is a recording of some sort," Marclay has said, "and a record is a kind of drawing; the groove is like an etching, but the difference is the extra dimension of sound, the sound transcends the object. The elusive vibrations of that spiral drawing need to be decoded by a turntable. This type of drawing needs a machine to make it vibrate into life. Or if it's a score, it needs a performer to interpret it. But when you watch somebody drawing or playing music, you can still identify with their physical presence."

Marclay's photographs and collages can be read, or played, like scores. Within the exhibition, there is the possibility of "hearing" the room, moving around the sequence of images as if each sounded its individual noise, notes or complex of sounds: a bagpiper plays outside a shop selling underwear, an abandoned church bells booms, the music of Charles Ives is thrown into a food blender, there are snatches of Elvis or the Rolling Stones. In one photograph, a faux red brick wall is stencilled with the image of an ear; the grain of plywood echoes the elaborate, elegant curves of the ear. The walls on which Marclay's images are hung become ears in themselves, hearing the implicit sounds which they display, yet simultaneously sounding (silently) as a single conceptual audio work.

There is an element of chance, in the way such a sequence will be "heard" by each viewer. This connects with the surprises of his video works, in which bizarre

and unexpected juxtapositions develop the narrative dislocations of pioneering John Cage works for electronic tape such as Williams Mix. One of John Cage's stories, collected for his "Indeterminacy Lecture" of 1958-59, then recorded in collaboration with David Tudor, describes a suspended mechanical pen seen in a stationer's shop window on Hollywood Boulevard, writing third grade penmanship exercises onto a mechanically operated roll of paper. An advertisement in the shop window praised the perfection of this device. Cage was fascinated, for the pen had run out of control, tearing the paper to shreds, splattering both window and advertisement with ink, though leaving the claim to perfection still visible.

Christian Marclay compares his photographs to the kind of sketches made by travellers, hasty recordings of memorable scenes as fragile as dreams in their tendency to slip from memory into a void of forgetting. "Now we have cameras – it's easier," he says. As in performance with many different records, they mark unrelated sequences of juxtaposition. Cage's anecdotes have influenced this way of seeing incident in accident; Cage believed, as he wrote in *Silence*, that "... all things – stories, incidental sounds from the environment, and, by extension, beings – are related, and that this complexity is more evident when it is not oversimplified by an idea of relationship in one person's mind."

Sounds jump into almost-actuality, just from the image: tin cans tied to the back of a marital get-away vehicle plunge us into indeterminacy and the surviving role of noise in contemporary ritual. A blue telephone sits on the floor in an empty apartment. The door is open. I think of an interview with Isaac Hayes, after his bankruptcy, sitting in an empty apartment with only a telephone. At some point, that telephone will ring. Within the silence of the photographic image, we can hear the echoes in that empty room. In a New York City fleamarket, a painting of a Spanish woman playing guitar left-handed sits among pots and pans. The wall is covered in graffiti; a music coalesces in our heads, Hispanic hip-hop flamenco with improvised metal percussion. A dog wearing a plastic cone collar, like one of Marclay's impossible hybrid instruments (his collage of a French horn fused with human organs) or an inversion of His Master's Voice, a canine loudspeaker: the woofer listening to tweeters. A car fitted with an inverted wire coathanger as a radio aerial. The radio only picks up stations that play clothing records, such as The Coasters' "Shopping For Clothes", Glenn Miller's "Silk Stockings", Run-D.M.C.'s "My Adidas" or James Brown's "Hot Pants".

Either in subversion or make-do, objects in a consumer society glide easily from one function to another. Marcel Duchamp is the grandfather here. Marclay creates silent objects which make us listen, notations for participatory audition. "Among our articles of lazy hardware," wrote Duchamp, "we recommend a faucet which stops dripping when nobody is listening to it." Marclay collages together Duchamp, *The Bride Stripped Bare By Her Bachelors, Even,* and the record cover of *My Fair Lady* (Pygmalion and Galatea being a recurrent narrative in his work), Eliza Doolittle hanging from the strings of her puppeteer (the bride being stripped bare by her bachelor), or he lays cassette tape onto photo paper and exposes it, in the style of Man Ray.

24

Just as Duchamp detached visual art from the retinal, so Marclay detaches sonic art from the aural. "I always rejected the idea of Duchamp as a master," says Marclay, who named his first band, The Bachelors, even, "but over the years I keep going back to him. He's inescapable." Inescapable in the sense that even Duchamp's experiments with oculism and illusion, the *Rotary Glass Plates* (1920) and the *Rotary Demisphere* (1924), can return us to the spinning discs on a record deck. Within the readymade of 1916, *With Hidden Noise*, is an object that makes a sound, the nature of the object known to only one man, Walter Arensberg, now dead. In 1920, May Ray photographed dust breeding on the surface of the *Large Glass* as it lay across sawhorses in Duchamp's apartment. Duchamp then fixed the dust with varnish.

Another Marclay photograph: the reflection of a tree in the glass façade of the Ecole de Musique in Paris. The tree appears to be growing through the soundhole of a guitar. I think of Max Ernst. Marclay accepts the connection. "He found the fantastic in the ordinary," he says. The photographs are triggers, shooting the gaze off into other worlds. As Cage says, these other worlds are our world. "It's like these little moments of recognition that we encounter every day," Marclay says. "They're small and insignificant. They need to have enough excitement to pull out the camera and press the shutter but most people pass them by."

For Marclay, sound always exists in a social context in which objects and iconography are fluid in use and meaning, shifting between levels of significance and textuality. Phones become bones. Paintings of music become silent records. Mirrors become feedback. His photograph of a canoe projecting from the back of a pick up truck draws my eye down to the number plate: Michigan WHISPER Great Lakes. Instantly, I can hear the silence of that canoe on the water. Watching his video piece shot in Texas, *Guitar Drag* (2000) – a Fender Stratocaster guitar plugged into a live amplifier then dragged at high speed from the back of a pick-up truck – thoughts come in a rush: racial killing, cowboys, Billie Holiday's "Strange Fruit", the Fluxus events of Nam June Paik and Robin Page, Sam Peckinpah's *The Wild Bunch*, Jayne Mansfield beheaded in a car crash outside New Orleans and the times I saw Jimi Hendrix destroy his Stratocaster on stage. *Guitar Drag* is another form of inscription, a drawing in the dust, a mysterious track connected by rope and guitar cable to a soundtrack; I thought of inscriptions in nature generating sound, such as the sound of a river or wind running through cavities and channels in rocks or buildings.

The history of recorded sound is a public archive, distributed unevenly through official archives and libraries, though largely among record collectors, music lovers, attics, garages, shops, fleamarkets and land fill sites. There is a sense of constant, infinite mix that has become both part of our cultural experience and a standard technique in the practise of much sound art and all turntablism. Among its many charms, Marclay's *Video Quartet* (2002) a mix of film clips ranging from Harpo Marx and Rex Harrison (*My Fair Lady* again) to Sean Penn playing guitar and Dustin Hoffman doodling on the vibes, illustrates human capacity to link unrelated events into a musical structure. In performance, Marclay overlays blues

and exotica, many unfathomable sources, tapping the records, slowing them, waving them in the air. They are objects and sound, the history of record sound, plastic circles, open mouths, secret language.

Inscrutable in its mass produced anonymity, a record makes a sound, even before the needle joins the groove, its black circle a Mary Quant hairstyle from the 1960s, the interior of a telephone receiver or loudspeaker, a Simon and Garfunkel song, "The Sounds of Silence". Materiality transmutes into aether; sound waves become substance. Mute is sound. In Marclay's work, the relationship between audible sound, an image signifying sound, a photograph documenting the enactment of sound, the notation of sound and the material aspect of a sound source are so closely threaded that our basic perception of distinctive, separate categories is challenged. Like the notorious National Enquirer headline—"Boy can See with his Ears"—Marclay asks us to abandon restrictive physical and conceptual distinctions. Hearing with the eyes, we see the world so much more clearly.

David Toop

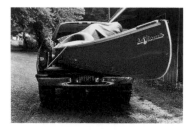

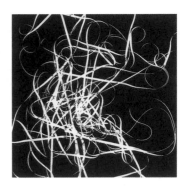

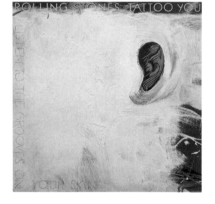

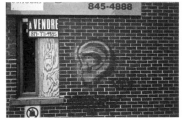

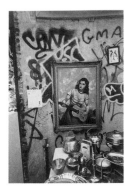

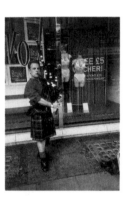

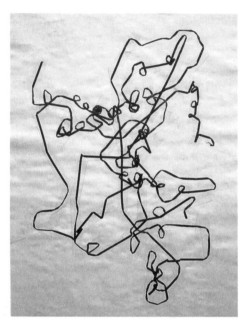

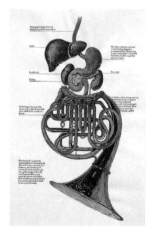

JOSIAH McELHENY

Model for Total Reflective Abstraction
(after Buckminster Fuller and Isamu Noguchi)

At the age of twenty, Isamu's sculptures showed such exquisite comprehension of anatomy and coordinate deftness of conceptual realization that his work resulted in his winning a Guggenheim Fellowship for travel in Europe. Arriving in Paris, he asked Brancusi if he might become his student. When Brancusi said no, he never took students, Isamu asked if he needed a stone cutter. Brancusi did. Isamu cut and polished for Brancusi in his studio, frequently polishing Brancusi brass and bronze sculptures. The scientist mind of Isamu pondered on the fact that sculptors through the ages had relied exclusively upon negative light; that is, shadows—for their conceptual communications, precisely because no metals, other than non-oxidizing gold, could be relied upon to give off positive light reflections.

I met Isamu Noguchi on his return to America, the year Henry Ford made chrome nickel steel commercially available for the first time in history and with it permanently reflective surfaces in economically available massive quantities. Isamu did not think of reflective sculptures as shiny alternate models of negative-light sculptures. What he saw that other did not see was that completely reflective surfaces provided a fundamental invisibility of the surface. This fundamental invisibility was that of utterly still waters whose presence can be apprehended only when objects surrounding them are reflected in them. Only the undulating reflections of ships' masts, tree and sky can inform the viewer that there are modulations in unwind-rippled waters. Seaplane pilots, making offshore landings in dead calm cannot tell where water is and must glide in, waiting for the unpredictable touchdown. This recognition occurred in the 1920s. Isamu saw here an invisible sculpture, hidden in and communicating through a succession of live reflections of images surrounding it. Then only the distortion of familiar shapes in the surrounding environment could be seen by the viewer.

In the brain of the viewer there would be induced a composite constellation of pattern informations permitting the secondarily derived recognition of the invisible sculpture's presence and dimensional relationships.

In this and other extraordinary physical behaviour explorations and experiments, Noguchi pioneered and communicated negative behaviourism of energetical phenomena a decade ahead of the negative energy-entity discoveries of nuclear physicists.

R. Buckminster Fuller in *Isamu Noguchi: A Sculptor's World* (New York and Evanston: Harper Row, 1968)

"I first met Mr. Fuller, as I used to call him... at Romany Marie's in 1929. Some time later I got an old laundry room on top of a building on Madison Avenue and twenty-ninth Street with windows all around. Under Bucky's sway, I painted the whole place silver—so that one was almost blinded by the lack of shadow. There I made his portrait in chrome-plated bronze — also form without shadow."

This was the same year that Fuller completed his plans for his metal Dymaxion House, and at other times he expounded on his theory of the "fundamental invisibility" of "completely reflective surfaces".

Isamu Noguchi in *Isamu Noguchi: A Sculptor's World* (New York and Evanston: Harper Row, 1968)

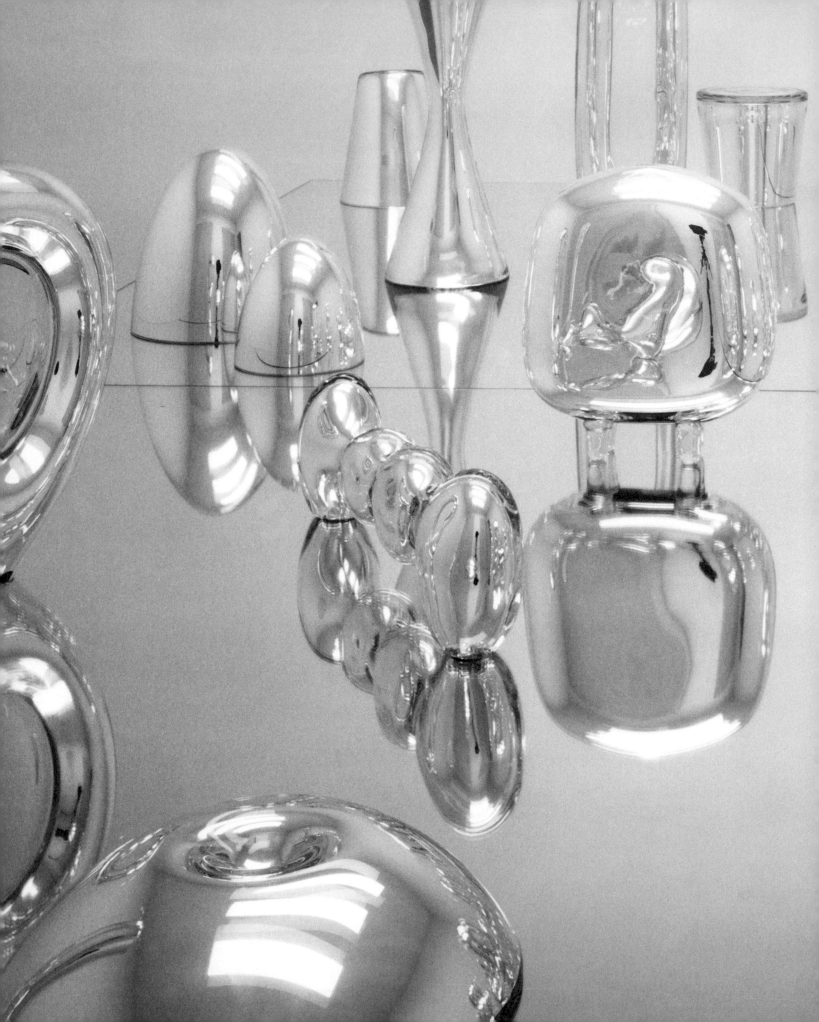

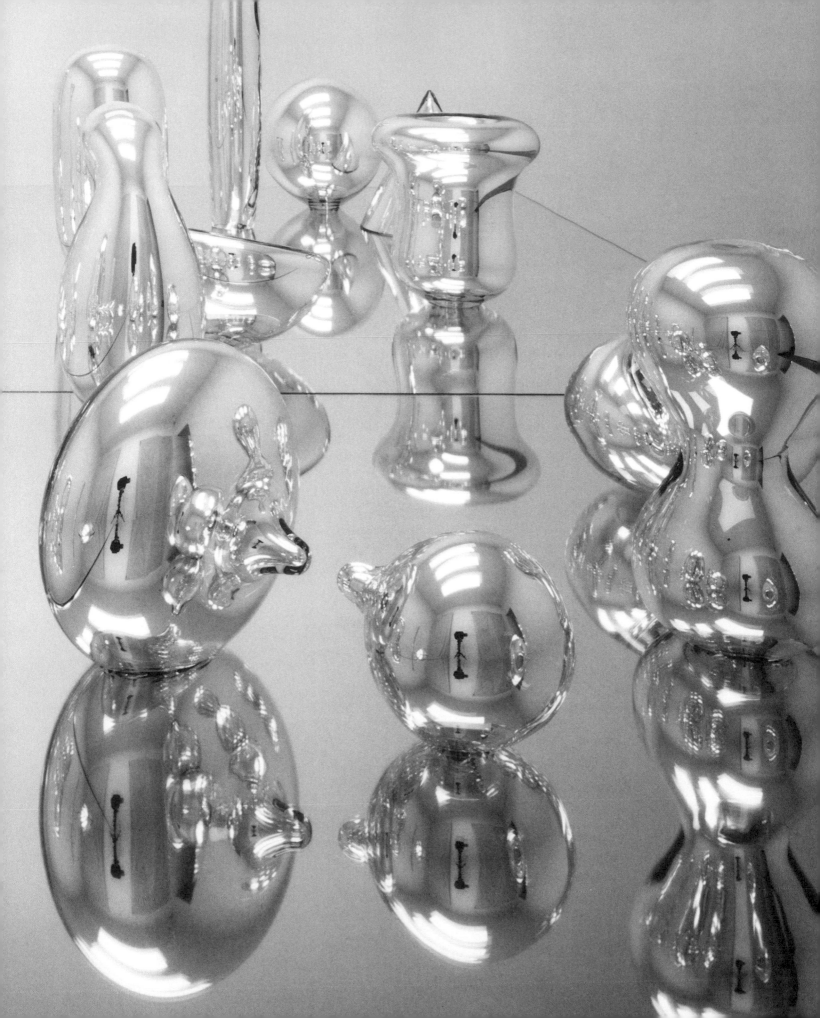

The oeuvre of Josiah McElheny proposes, literally and conceptually, a keen reflection on the essence and limits of artistic creation and the tensions between reconstructing and imagining history; between the fabricated and the appropriated object; the original and the copy; between architecture and the objects it contains; the notion of display and how it affects our viewing of an object. With his earlier glass recollections of objects linked to historical or literary episodes with explanatory texts in museological style, McElheny managed to build a bridge between tradition and modernity, while questioning the nature of the artistic object.

By gathering first-hand expertise and knowledge from different cultural quarters of the glass-making industry, McElheny has developed a critical attitude to glassmaking that enables him to work both inside and outside of his chosen idiom. An expert and erudite glassblower, he deconstructs the industry, not as a moralising postmodern gesture but rather for himself, in order to inhabit other, more fertile identities that allow him to move freely between different zones of cultural knowledge and bodies of individual knowledge and create new images and expanded meanings for the same world. A true "master of glass" in terms of his deep understanding of the literal and metaphorical potentials of his medium, he is also an interloper, an extraterritorial, in every sense of the word.

His work with mirrors, for example, not only involves making objects to be physically apprehended, but equally the history of the mirror as object and the history of reflectivity, and how these interdependent histories have been affected over time by changing technical, aesthetic, philosophical and cultural attitudes. As he succinctly observes: "Although mirrors are objects, we don't really perceive them as such; we tend to think of them only in terms of functionality, as reflecting surfaces fused to the wall, but historically, they were objects in themselves, important architectural features, windows onto other worlds. We take the perfection of the mirrored surface for granted now, but the mirror was a very different physical object at different points in history, and the reflection it created always related to how people saw themselves at any given time."

His earliest work on this subject, *The History of Mirrors* (1998) told the story of the technological development of the mirror, from the polished volcanic obsidian or "dark glass" to the heavily decorated mirrors of the eighteenth century. This was followed by a work directly inspired by Jorge Luis Borges's poetry and essays on the subject that discusses mirrors in both a Western and an Eastern sense, the former being an image of the self communicated through the science of optics, the latter being the glimpsing of the self in imperfect reflecting materials such as polished stone or wood. Borges's verse reveals that both genres of mirrors and their "uninhabitable, impossible space of reflection" disturb him in that their clarity or distortion show him "another Borges," separate from himself, unattainable. *Possible Mirrors* (2002) employed yet another scale and rhythm to explore the disturbing place of Borges's perception where images are formed, arrested and subjected to a process of ever changing potential.

In his recent New York exhibition "Theories of Reflection", which made reference to a wide range of historical figures from seventeenth century polymath Anathasius Kircher to twentieth century utopian Buckminster Fuller, McElheny spun his investigations of reflectivity into dizzying new sculptural dimensions. Working entirely with blown mirror glass and mirrored displays, he created reflective objects designed to inspire reflection, a rhetorical construct that proposed contemplation as a function of physical effects. *Buckminster Fuller's Proposal to Isamu Noguchi for the New Abstraction of Total Reflection* materialised the imagined results of Fuller's claim that Noguchi had invented a new shadowless abstraction of totally reflective objects. (Their original conversation happened in the late 1920s when Noguchi had just returned from apprenticeship with Brancusi, where his job was to polish the sculptures to a reflective level beyond the human eye's ability to perceive); fittingly, McElheny's usual clear conceptual strategies turned into an enthralling visual labyrinth of order and chaos.

McElheny has continued exploring how ideas become intertwined, informed and extended by their material form in a large-scale work *Model for Total Reflective Abstraction (after Buckminster Fuller and Isamu Noguchi)*. This is, perhaps, the ultimate work of the mirror-glass series, a large floating plane or base of mirror on which sits a landscape, model, or "garden" of McElheny's interpretations of Noguchi's sculptural forms in all materials, all rendered in totally reflective handmade glass. Importantly, this work departs from a true historical anecdote, reimagining, and thus heightening, the possible consequences of that narrative. Here, I discuss this extraordinary work with McElheny, continuing a conversation that we began in 2001 as "The Glass Bead Game" (in *Josiah McElheny*, Centro Galego de Arte Contemporaneo, 2002).

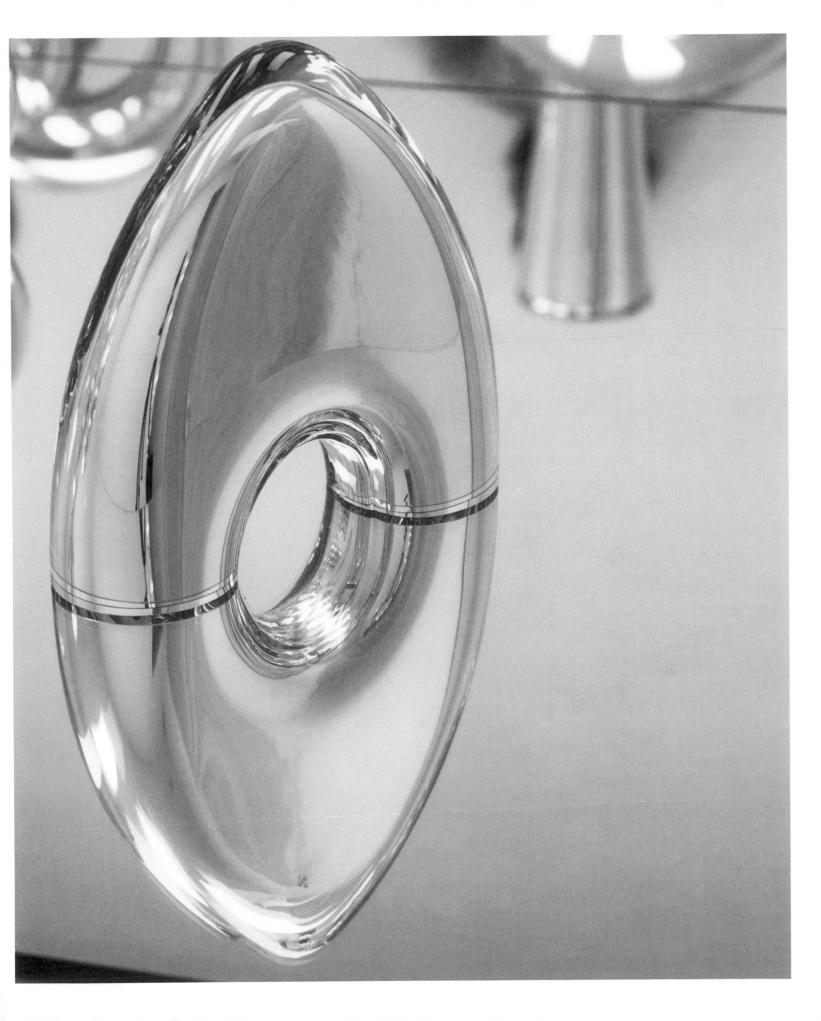

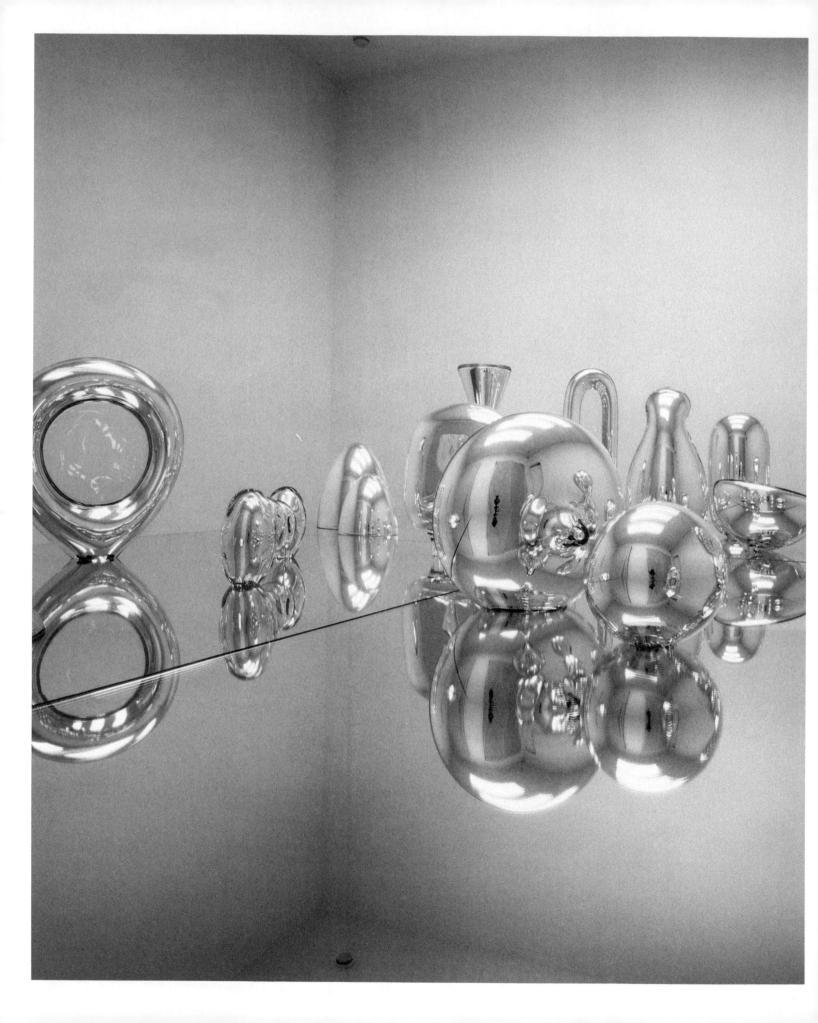

The Glass Bead Game Part II

Louise Neri: One of our principal topics is your interest in the history of mirrors in terms of the history of meaning, and how this relates to the development of the human psyche. *Model for Total Reflective Abstraction (after Buckminster Fuller and Isamu Noguchi)* could be perceived as the apotheosis of the rhetorical relationship that you have identified and described as existing between material reflectivity and self-reflexivity. Also important is the way some of your works propose that the Modernist impulse is not specific to an historical period, but can be traced literally and metaphorically to a much more distant past via a discussion of form, just as Henri Focillon argued so persuasively for the Baroque as an impulse that could be physically detected at many different moments in time throughout cultural history.

Josiah McElheny: *Model...* is informed by the notion that *the act of looking at a reflective object could be connected to the mental act of reflecting on an idea*, that these activities are not very different at all. And that the physical/mental experience of viewing *Model...* could demonstrate this very directly. Raising the issue of the human act of perceiving versus the eye of the camera proves my point to some extent; because of one's necessarily conscious involvement in the perception of reflective objects, these objects cannot exist independent of one's self. I am interested in the idea that the materiality of reflectivity itself contains a variety of ideas, concepts, and conundrums.

L: Perhaps one of the most powerful things about *Model...* is its very embodiment of subjectivity. Viewing this work, one becomes very aware of one's own subjectivity; one's "eye" and how it differs from that of the next person; how one's human perception takes in the whole image in a sweep. I'd even go so far as to suggest that this piece actually *dematerialises* under the viewer's gaze because it consists only of surface, reflection, refraction, and distortion. The baroque distortion that occurs via its unstable surfaces creates an endless play. Once this process is set in motion, there can be no end to it. As one moves around it, relations and responses are activated that are instantaneous and fleeting. *Model...* is thus an incredibly "dense" work. But, despite its inherently cumulative nature, you have created a paradoxical impression that it is a "dematerialised" object, without substance, a mirage. In conceptual terms this is very fascinating, to be looking at the reflection of an object, never the object itself.
It's also worth noting here that you have deliberately juxtaposed an industrially produced mirrored base that has a perfectly even reflective surface with a collection of man-made mirror-glass objects, each one with its own irregularities and distorting surfaces. The philosophical dichotomy presented here is a subject in itself.

J: I made a conscious decision to include the contrasting kinds of reflectivity, seen in the base and the objects. I wanted to create an oscillation between

the objects and a surface that is so banal and familiar that the viewer ignores its presence. It disappears, but then suddenly returns as a surface of fascination because so much is reflected in it. I'm suddenly reminded of the anecdote that someone at the opening told me, how as a kid he would walk around the house with a mirror and view his surroundings through it rather than directly.

I'm excited about what you say regarding the dematerialising of the object; it reinforces my belief that the object only exists with the participation of the mind. *Model...* tries to manifest this premise. Fuller and Noguchi entertained a theory of abstract forms without shadows, in which form existed in a different way. In a sense a reflection is a shadow but at the same time it isn't. In a reflection, the figure/ground relationship disappears and the figure and the ground becomes as one.

L: It's a profound statement if you think that the shadow was always considered to be the evidence of the soul. Historically, the shadow and the soul have always been inextricable, sometimes even interchangeable. To have a shadow was a sign of being human.

J: Well, actually the recent version of Strauss's opera *The Woman Without a Shadow* that I saw at the Met was an inspiration for this piece. Herbert Wernicke's set was a gigantic mirrored box on which the whole opera took place; the dramatic change of scenes were created solely through lighting changes; and the woman's shadow was represented by her reflection.

L: Your thoughts concerning the theory of total abstraction reminds me that your work has always contained a strong conceptual dimension. You have often integrated text into your works, but this time you have managed to communicate the intellectual dimension of your work through purely visual and experiential means. We can therefore surmise that the work itself functions as a mental image, in fact that it *only exists in the mind*. Looking at it, we are forced increasingly into the realisation that it is only the state of our own perception of the artwork itself that makes it exist.

J: I'm always thinking about how the viewer finds a way into my work. With the whole body of mirror works—its basic premise being the fusion of mental and perceptual processes aided by specific titles but otherwise without additional text—I feel that I have learned a lot about *where* meaning resides in the visual experience.

L: It's also interesting that the last work in the series is a work without a centre; you've created a visual field rather than a visual vortex.

J: Some of the earlier works in this mirror series were more like windows on to other worlds. This particular piece is very exciting for me because the viewer walks around it and at the same time is engulfed by it.

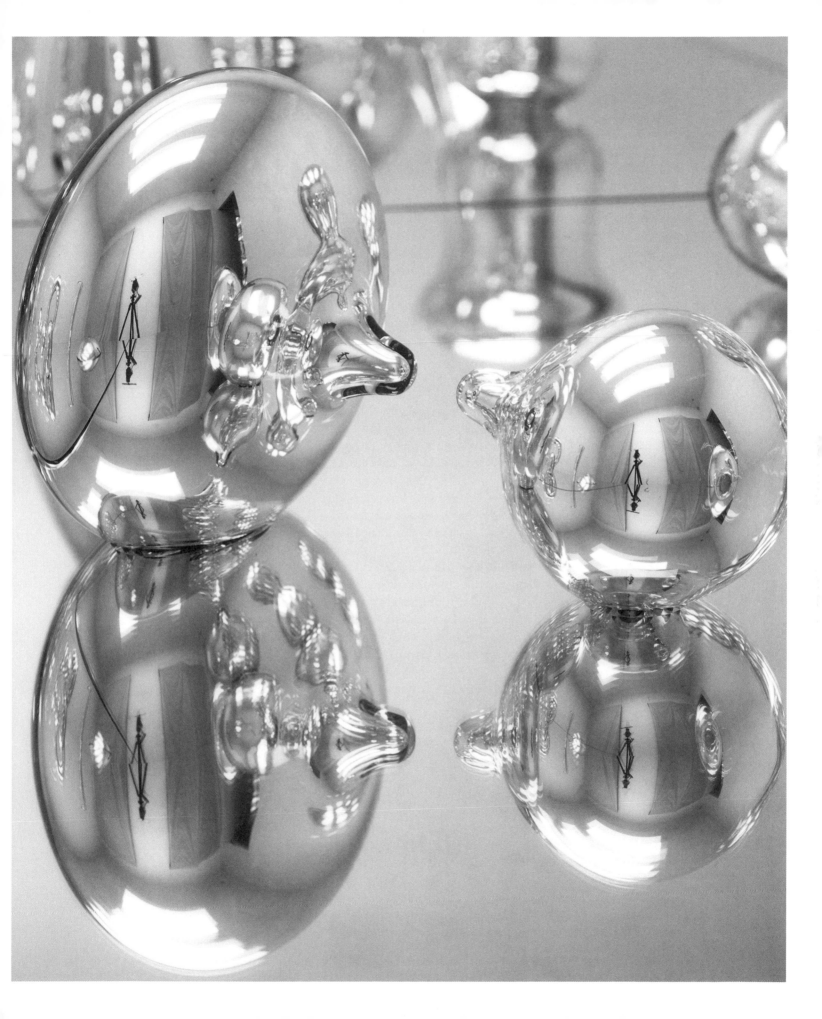

L: You've made a reflective piece that the viewer looks down into. You're forcing the perspective to a very dramatic degree. An earlier work, *Buckminster Fuller's Proposal to Isamu Noguchi for the New Abstraction of Total Reflection* (2002) is tabletop height; *Model...* with its low base refers to other display modes such as bases for commercial displays and so on. *Model...* literally sucks the viewer into its reflectivity: looking down into it, one can't help but see oneself reflected. It makes me think of Narcissus, Lewis Carroll, and the scene in Cocteau's *Blood of a Poet* (1930) where the poet falls into a mirror; he is supposed to be passing through a wall, but it seems that he is falling.

We've talked about your oeuvre before in relation to models. *Model...* more than any other work recalls architectural models of cities; at the Musee d'Orsay there is a scale model of the city of Paris set into the ground with a transparent floor above on which viewers stand and look down into it; this gives a similarly reflective impression. What you are doing with *Model...* certainly isn't miniature, but there is something about the proportion of this piece that seems very significant. Can you discuss this?

J: The concept of the model is very much part of this piece, as even the title itself indicates. I hope that turning an idea into a "model", as opposed to a "reality", is a gesture that suggests the ability to imagine one's own alternative models.

Of course a "model" always has a specific scale in relation to reality, and I think that this allows imagination to function in a particular way. If you think about architecture in the twentieth century, one of the things that made it possible to create the giant schemes of modernism was the scale model itself, which allowed the patron to imagine his or her relationship to the architect's structures. But often architecture fails in the transference of scale: History describes many episodes in which the gesture of abstraction, of utopia, of creating another world, when it moves from model to reality, the reality becomes monstrous, fascist, totalitarian.

So, the idea of creating a possible model, an unrealised proposal, perhaps is my central point: that a way forward in the life of ideas or in the continuation of imaginative possibilities lies in the scale of the gesture. A "model" for abstraction or utopia is a gesture on a scale that can survive.

L: I'm reminded of our last conversation in which we talked about "using very small things to express very big ideas".

J: When talking about the "scale" of a work of art, I'm referring to both its physical and mental scale. The mental scale of the model is what I was referring to just now; physical scale is another aspect. I tried to use scale very specifically in relation to the given space of this project. I played with the exact height of the work so that the viewer would be able to perceive it both from in front and below. The objects themselves are a very specific size.

I don't understand it myself completely, but it seems that there is certain scale of object that, whatever the cultural context, can have impact without being too large. Something between 12 and 20 inches (30-50 cm). If it gets bigger than that it exceeds the model relationship to the adult human body.

L: Maybe because it relates to the scale of the human hand and what it is capable of holding, or the size of the human head - a sort of Archimedean concept of symmetry and reciprocity at play, which brings a whole other meaning to the concept of "reflectivity" here: the relationship between viewer and a group of objects, or a group of viewers and a group of objects gives the idea that this work is a "conversation piece" in the classical sense of the word.

J: That's exactly how I hope this work is perceived, as a conversation piece whose open configuration creates constantly changing relationships of the objects to each other within the viewer's perception and thereby endlessly generates new thoughts.

L: This, together with the speed of vision and phenomena of disappearance and dizziness that one experiences in the presence of this work, contribute to its highly baroque nature. That one gets drawn into the "negative space" of the work; that one's perception of oneself disappears in the process of looking; that one can only ever see a wildly distorted version of oneself: there are many folds in this piece and one can disappear into it entirely.

J: If you spend enough time with it, first you see yourself reflected once or twice in certain parts of it, but after a few minutes you realise that you are being reflected thousands of times everywhere. It must have something to do with how the human mind works, and how it blocks or admits multiplicity...

L: This tension that you describe between not seeing oneself at all and seeing oneself everywhere is a profound point. These dichotomies echo through all the different responses that one has to this piece. Another characteristic of the Baroque is the extreme performativity of so-called inert surfaces; for example, when you move into a Baroque architectural space, suddenly the impression that the room is starting to move around you.

J: And yet the piece is physically inert. Some people find the mirror works and my previous white works very cold, while others find them playful or sublime...

L: Maybe you're saying that they are extreme?

J: I heard Jorge Pardo say once that his main interest in his own work was in asking what is the absolute minimum he could do to create an empathetic, mirroring response in the viewer...

L: And in your case it's rather what is the absolute maximum!

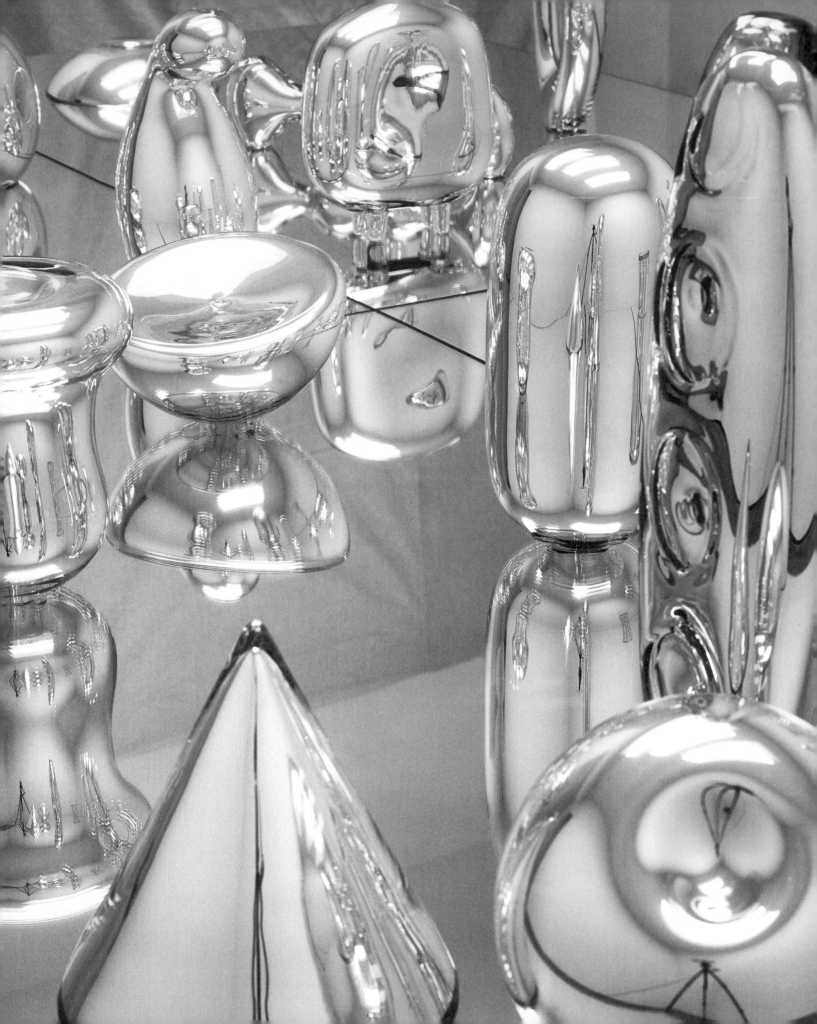

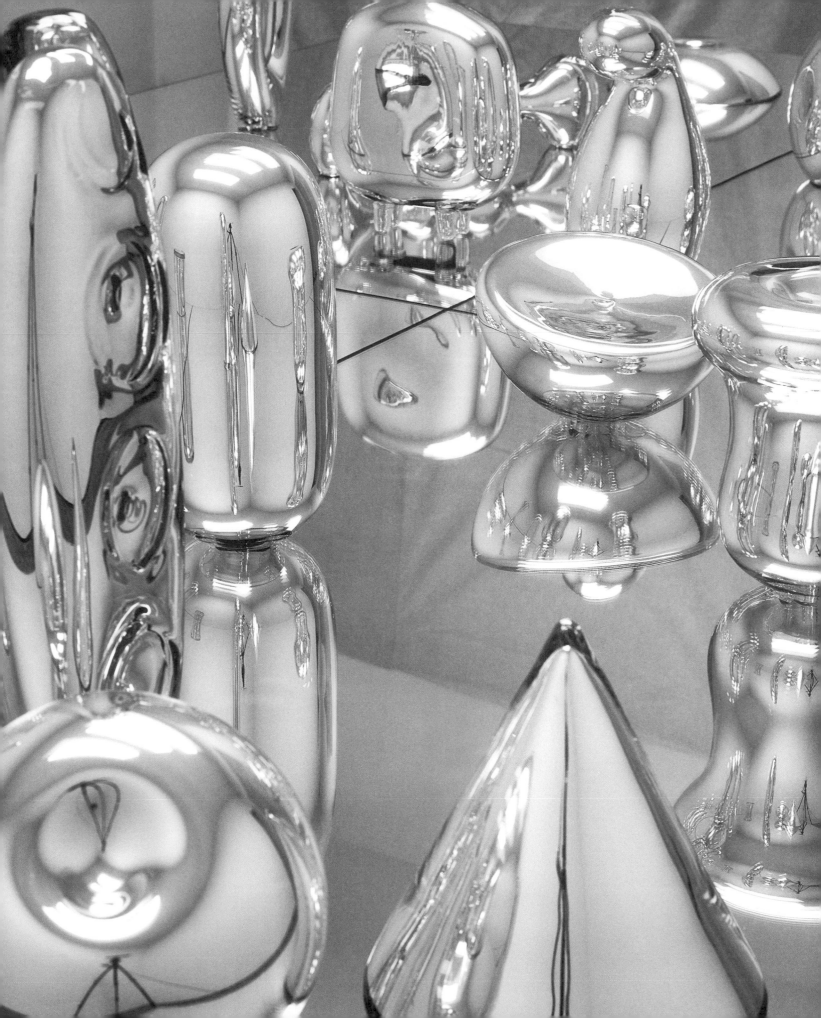

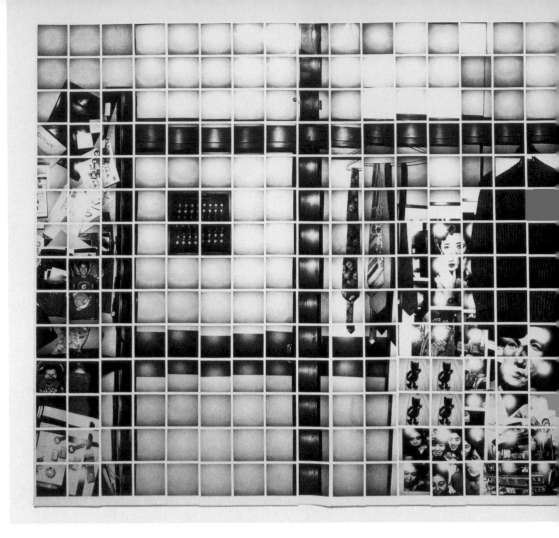

DAIDO MORIYAMA

Polaroid Polaroid

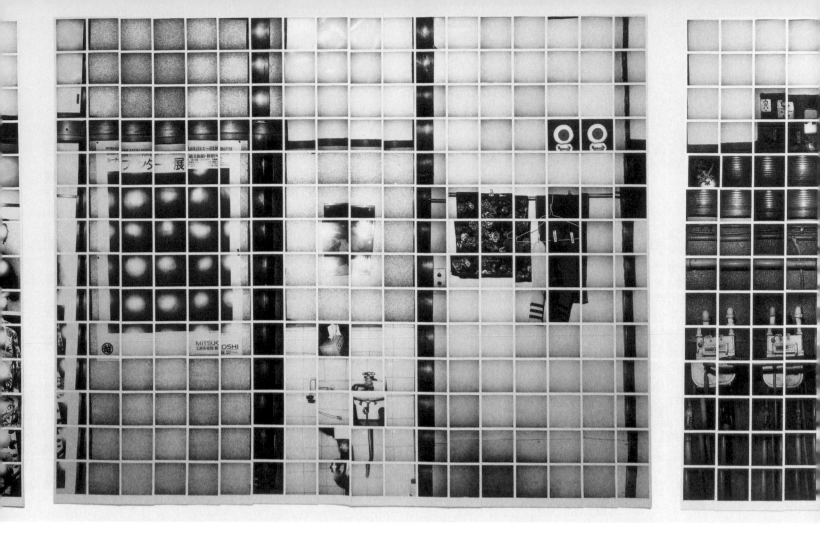

Daido Moriyama and the Rhythms of Photography

Daido Moriyama's work has always found ways to infuse qualities of edginess and apprehension into scenes which, taken at face value, would normally appear as neutral to the point of being overlooked. One of the many strands in his work directly replays strategies from classic Surrealist photography. Not only are there shared motifs — headless mannequins, high-heeled shoes, fishnet tights, a fedora — the goal of the image seems closely related: to take an ordinary object from the world and to discover or project into it a maximum of affect — affect which at the same time seems disjunctive and arbitrary, unrelated to the object itself. When Moriyama photographs two wheels from a truck, or sections of heavy chain, or a car wash, somehow these banal objects and scenes are made to release an emotional charge that fills every surface with dread and foreboding. A cluster of vending machines on a deserted street corner in Tokyo conveys the feeling of a catastrophe only seconds away. A

49

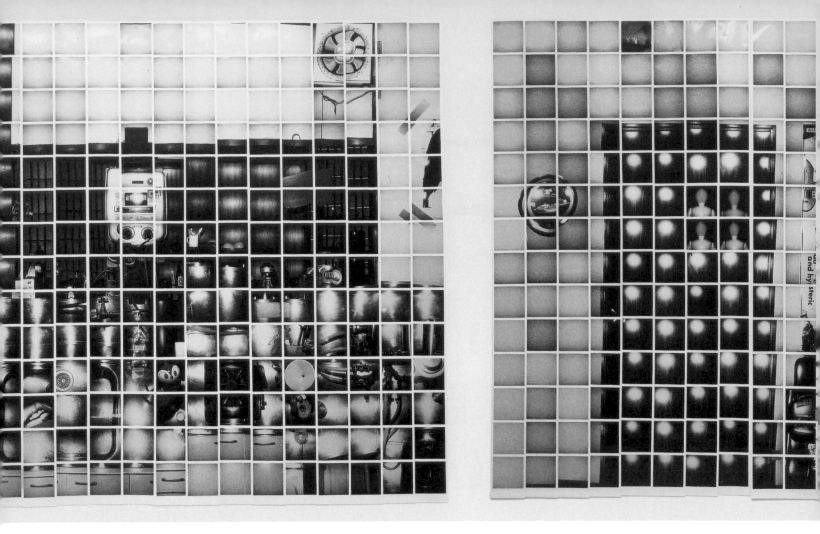

group of men sunbathing on the beach, portrayed with the same kind of
chiaroscuro that Hosoe Eikoh used to photograph Mishima in *Ordeal by Roses*,
suggests beneath its nominally casual subject matter the presence of dark and
dangerous flows of desire, a life force half in love with its own destruction.

What Moriyama — like the Surrealists — is able to pinpoint, through this kind
of misalignment of the object with its affect, is the way that, in everyday
reality, visual objects tend to be accompanied by cultural cues that indicate
quite precisely how they should be subjectively processed. An entire web of
conventions spells out what is worth looking at, or not; what is to be admired,
or found disgusting; what is glamorous, or touching, or comical. The objects
and scenes that surround us are tightly held in place by repeated patterns of
association that enable the subject to navigate a normalised path through
visual experience. The great discovery of the Surrealist photographers was
that the camera, however, is not exclusively governed by such codes and

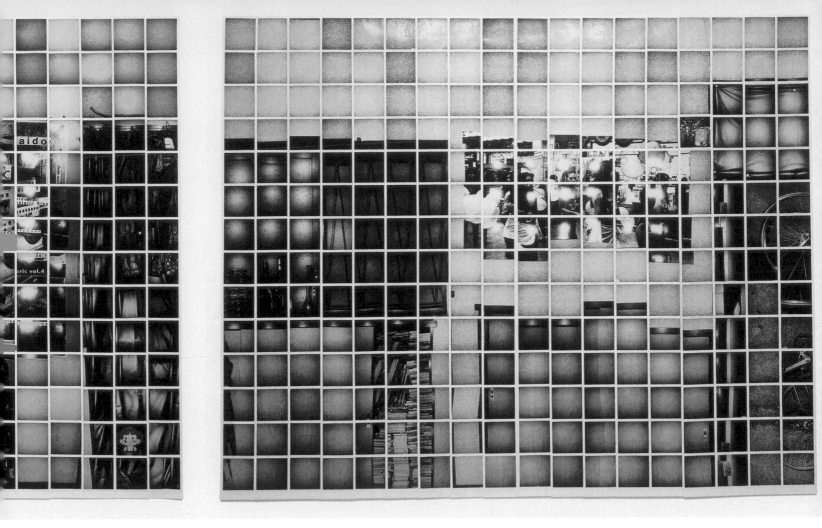

protocols: what should be repellent to look at could now be seen as beautiful, or banal objects as mysterious or sublime. The camera revealed an ability to cut through the lines of code that tied objects and scenes to their designated values and feelings, and to forge entirely new pathways and connections. To that extent, the camera opened up, at least in principle, a wildly asocial mode of seeing: photography shows the same outer world that we all share in common, but with a dramatically unpredictable range of emotional and psychic resonances. Moriyama's famous *Stray Dog, Misawa, Aomori* (1971) sums up this potentiality of the camera to represent the world from a radically anarchic or non-socialised viewpoint: inhabiting the same spaces as the rest of the social world, the camera can nevertheless occupy a position of deep estrangement, a heterotopia that is way off the social map of normalised, routinised reality. Hence the chilling and disquieting atmospheres that pervade Moriyama's urban scenes, as though at some dissolving edge of the city, normal social codes begin to peter out and the city of bars and mean

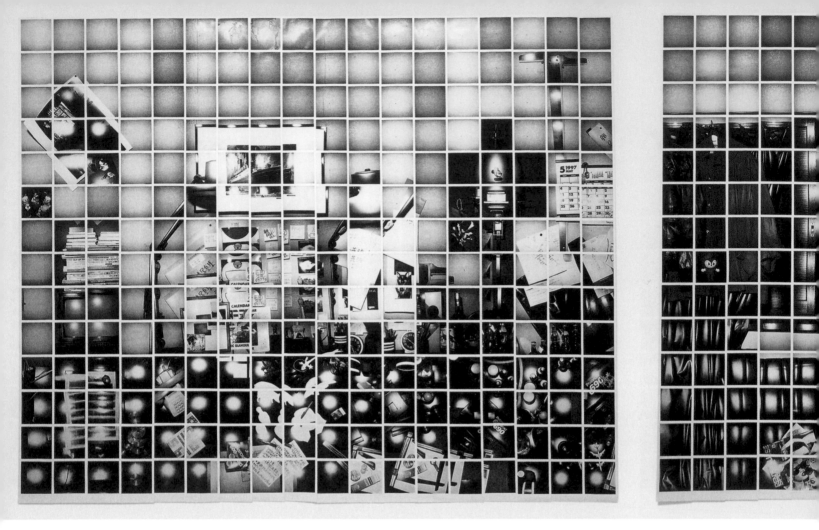

streets starts to lose the urban plot altogether, becoming waste land and *terrain vague*.

Yet what complicates this understanding of Moriyama as a latter-day Surrealist is the centrality in his work of the thought of mediation, and of the photograph as a mediated object. Certain remarks make this clear: "...from childhood my territory of interest has been my love for printed things: posters, billboards, film stills, screen prints, and illustrations. In school I remembered only photographs or textbook illustrations. This is how I have lived day after day, not only in the real world, but also and much more in the copied world." To Moriyama, "the people printed in dots appear to be more vivid and direct ... than the people standing in front of me." This points to a quite different aesthetic from that of Surrealism. There, the key moment occurs when the ordered and socially normalised world is broken into by a force lying outside codes and conventions, by what is raw, primal, closer to the unconscious. With Moriyama, it is almost the opposite: the key moment is

52

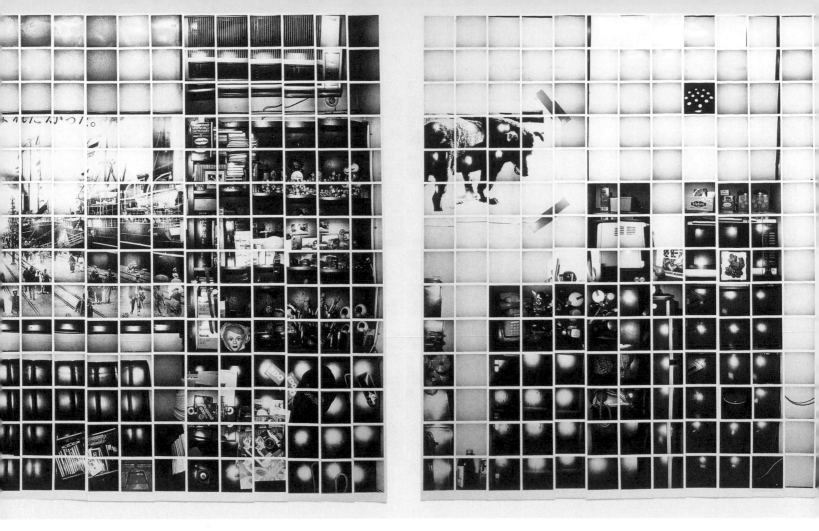

when what is real is eclipsed by what is coded and mediated ("dots"), when
empirical experience is overtaken by the world of representation.

This is exactly the sense conveyed by each of the myriad instant photographs
that make up *Polaroid Polaroid* (1997): the defining moment of each square is the
split second when what is real becomes representation. Here photography's
significance is not that it records the world but that it replaces the world:
until the moment when it is photographed, the object in the world is vague, not
fully substantial, not fully an event: it is the camera that confers on the
object its full weight and ontology. Although one can imagine that the series
might have unfolded in Moriyama's usual territory — out in the city, in Shinjuku
or Shibuya — what is essential is that it is a work that takes place in a
domestic interior. The external world is shut out, kept at bay, and the city
shrinks to the size of an apartment. Then, in a second step back, the
miscellaneous objects of the apartment (books, clocks, pens, lamps, umbrellas,
tea-cups, calendars, framed photographs) are distilled into an image, with each

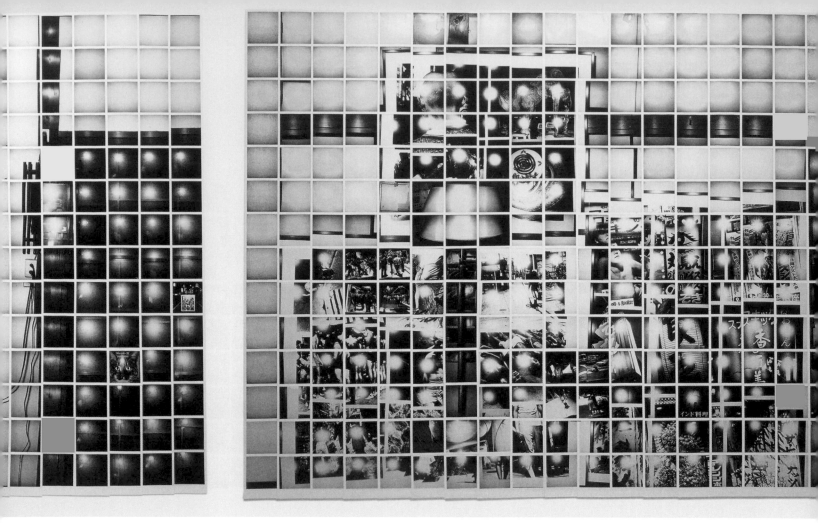

item replaced by its photographic replica. The inwardness of *Polaroid Polaroid*, the fact that its *mise-en-scène* is the intimacy of private living quarters rather than the open spaces of the city, is important in that this retreat of photography away from the public domain removes the dimension of narrative or allegory that often attends Moriyama's urban work, especially in critical commentary. Recurrent in writing about Moriyama is the *topos* that his subject is post-war Japan, in the period of its rapid re-industrialisation, Americanisation, and restructuring of values. While this emphasis is not wholly inaccurate, it tends to frame his photographs within a grand narrative structure that can interfere with the subtler effects of his work. *Polaroid Polaroid* blocks such cooptation by master narratives through its commitment to still life, to domestic objects that, through their sheer familiarity and ordinariness, lack major narrative resonance. What replaces public narrative is the detritus of ordinary life, objects in Moriyama's immediate milieu – kitchen stores, plumbing, furniture, drapes – that possess only low potential for narrative

54

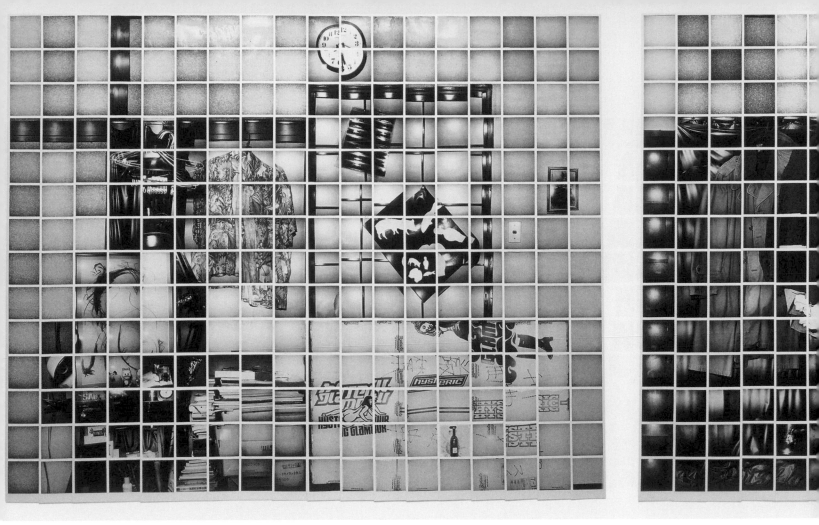

recruitment. Or, when a personal dimension seems to emerge (black rubber drapes, an inflatable doll) it is one we can only guess at. This absence of any ulterior motive or story allows the series to concentrate without distraction on the central moment of each component element, when the object passes from the world of experience into the world of representation. At this key moment, photography emerges as a kind of visual alchemy, turning base matter — the insignificant details of a personal habitat —into the gold of the photographic image.

With much of Moriyama's work we see only the final product, pictures of enormous force and suggestiveness, dark and unforgettable. *Polaroid Polaroid* is fascinating in that it shifts from the photographic product to the photographic process, taking us backstage or into the workshop where images emerge into being, some in their entirety, others only in fragments, some clearly defined and others only half-formed or still forming. Reflecting on photography as a process of transmutation from base matter into image, the series portrays the essential

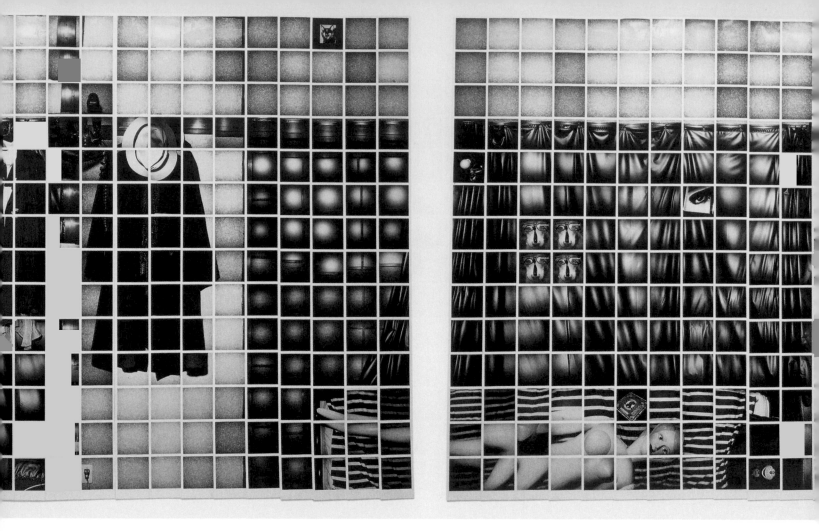

rhythms and flows that operate as the moment of photographic alchemy takes place. What is essential here is that the uniformity of the grid, with its connotation of an outer world objectively known and measured, is constantly interrupted and cut across by the new flows and speeds of photographic attention. Sometimes an image emerges slowly and provisionally, not arriving at a final forms (walls, drapes, cables), or sometimes it leaps at once to a definitive, self-enclosed form (tea-cup, bottle, gloved hand); while for whole stretches of time no image seems to arrive at all, and instead there is only flickering and flashing, a stuttering on the threshold of a legible form.

In many accounts of the nature of photography, the photograph is said to belong to the world of the instant, the "perfect moment," suspended or captured in a singular image standing outside time. *Polaroid Polaroid* is unusual in that, by spreading the time of photography laterally (its component sub-images, numbering over three and a half thousand, were taken over three consecutive days) it is

56

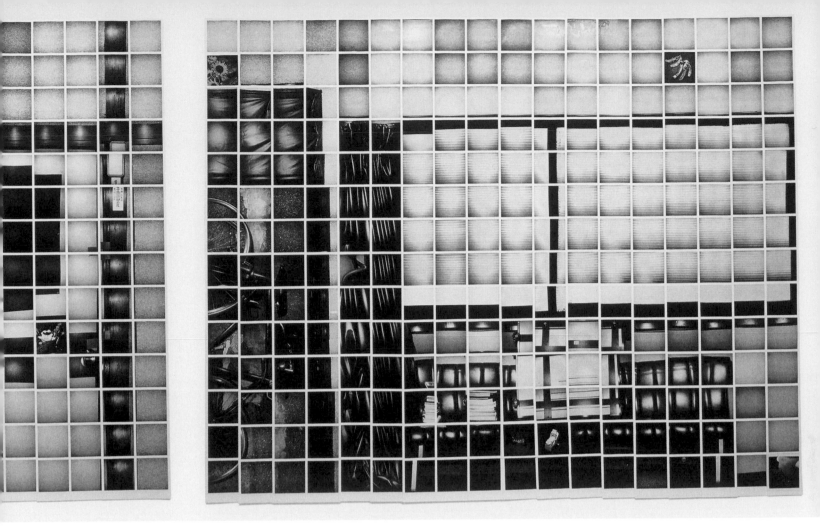

able to place photography in relation to time and to flows of intensity, as a series of rhythms that move through time across the visual field. Instead of the perfect moment, the work describes photography as working with conscious attention in ongoing time, constantly changing the scale and mode of attention that is brought to bear on vision, accelerating, slowing down, skimming over the blandness of an empty surface, or engulfed in a welter of intense detail.

Moriyama's originality is to think of photography not as a record of the world (mimesis), or even as a work with Form, but as a medium that turns the base matter of the world into the flows and fluctuations of the image, across complex frequencies of attention and relaxation, where the image arises, holds for a while, then ebbs away in the living time of the camera's quickened attention.

Norman Bryson

KATHARINA GROSSE

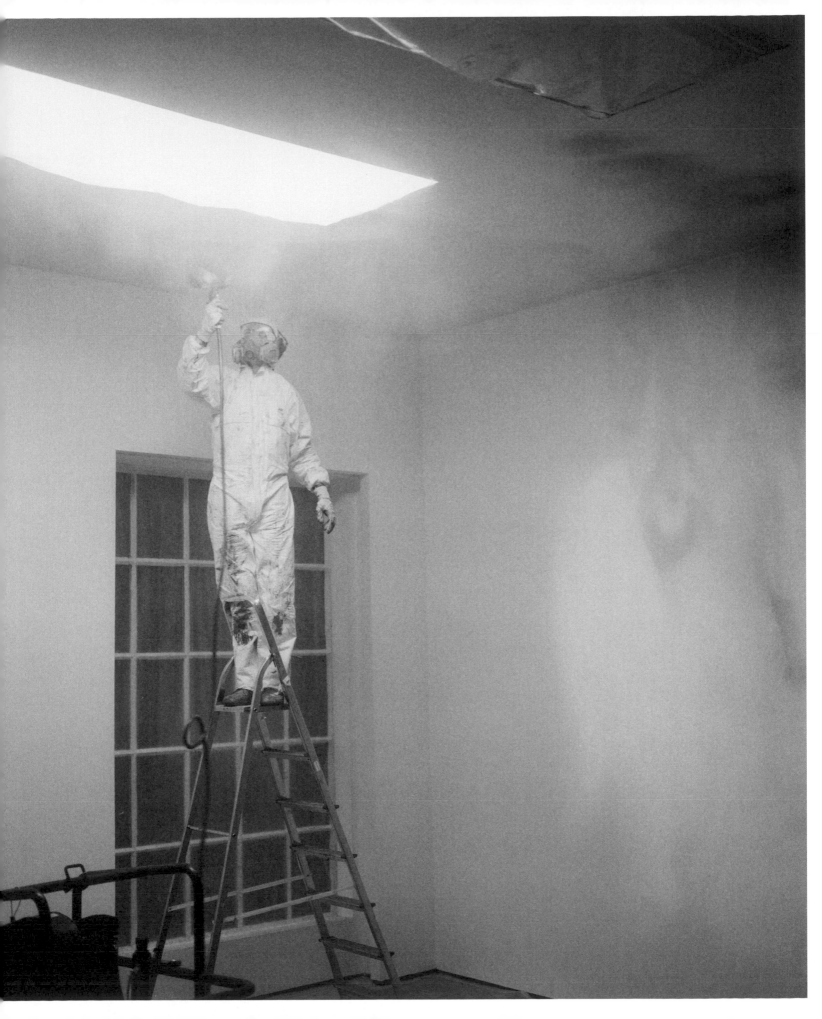

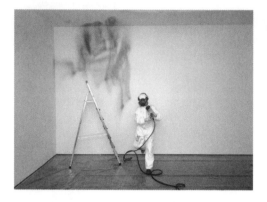
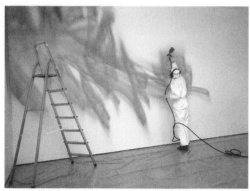
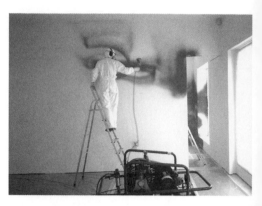
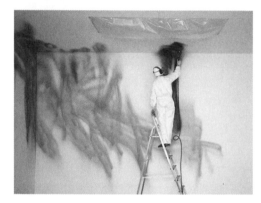
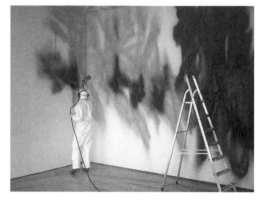
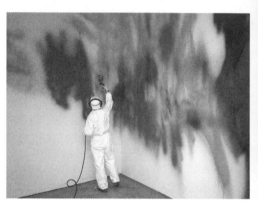
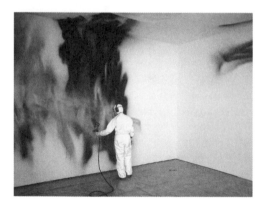

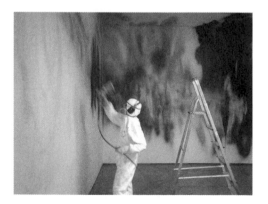
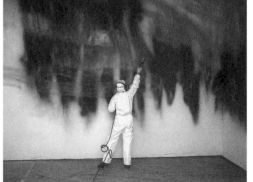
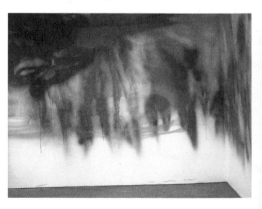

Just days before the opening, Katharina Grosse's painting for Inside the White Cube was yet to be made. Within the time remaining, the painter would begin and complete a large, invasive work, using the diffuse impact of a compressor to explore and evince a new and highly dramatic physiognomy for the pragmatic container of the existing architecture.

Whether working site-specifically or autonomously — she also paints on canvas, aluminium and paper — Grosse's working process might best be described as stochastic: skillful and intentional, yet exuberant and open to chance and random variables in the articulation of different layers, reaches and depths of field, harmonies and clashes of colour. Like the improvisation technologies of dance and music, hers is a highly conscious act that embraces the outcome of its first phase of activity in a non-judgmental way; in other words, nothing can go "wrong" or "right" in terms of the final outcome.

As with all abstract art, Grosse's work could be said to function purely in terms of *Gestalt*; and yet, conversely, it is in this most essential, so-called indivisible quality that hybrid metaphors, associations and contradictions proliferate. Laurie Anderson once sang, unforgettably, that language is a virus, and in Grosse's control, the sublime language of abstract painting turns virulent and deeply evocative as it "contaminates" the blank space and its surroundings in a sudden release of baroque energy.

Painting in the Expanded Field

Louise Neri: You work directly on walls, using the architecture as your support, thus your work immediately assumes an environmental rather than object status. Is this painting as attitude rather than form?

Katharina Grosse: The way you asked the question already shows that my work can, of course, be understood through historical precedent, how other artists have used "the space", from cave painting to Renaissance painting to avant garde conceptual strategies. But my personal attitude is very simple: I have always painted on architectural supports since childhood. When I began to study art, I found abandoned houses and made huge charcoal drawings directly on the walls, never caring about what would happen to them. So, you see, it began as a natural impulse, which was put into context later.

L: What prompted you to use spray paint?

K: I was making wall paintings with paintbrushes, following the format of the wall itself. It occurred to me that I was working as if with objects and I thought that my painting should be more independent from the space and its surface. This is what spray painting allowed. I use the space and the surface but I don't touch it, feel it, and fetishise it. I'm quite detached from it

because of my mask and protective clothing. I watch myself doing it. I see the paint hitting the wall in front of me; the implement does not obscure it, as with a paintbrush.

L: You make strange a process that is usually intimate. You're small in relation to the image you create, as is the viewer, like Friedrich's person in a landscape. As well, you're sealed in a space that is largely obscured from you by flying paint; in your protective clothing you look like an astronaut, or a worker in a restricted industrial environment; you're connected to the paint compressor by an air lead, a kind of cyborg, half-woman, half-machine. This image places you in a perverse relationship with painting and its traditions.

K: I'd call it "romantic irony". For me, true Romanticism is a very remote idea about one's own reasons for living on this planet. It's ironic that such a big fuss can be made with paint! I'm more ambivalent. I draw on many traditions in painting but at the same time I use a technique that is cheap, associated with car finish and graffiti. For me, this can be a productive approach to Romanticism, not Caspar David Friedrich — although being at the edge of the painting is quite an interesting idea.

L: When you speak of "romantic irony", I think about the vast associative dimensions that the sheer excessiveness of your work communicates: among many other things, toxicity, artificiality, expenditure, exuberance.

K: I consciously include elements that have nothing to do with this other status of painting and its associative elements. But then, all of a sudden, a metamorphosis takes place with the interference of external referents. I could be very clear about what I want, but I don't want to make an easily identifiable image. That's where the process starts to be a secret language. Ultimately, an image is enigmatic because it can't really be taken apart. Sometimes I don't know what it is myself; sometimes it's just that the painting ends.

I chose to work directly on a wall with a spray gun to reveal the intrinsic qualities of paintings. Paintings operate with a very different idea and understanding of the rules of space than architecture and sculpture. But, paradoxically they need these structures to show the linking of pictorial space with architectural space. This fact makes all these thoughts bounce back and forth. So I am constantly dealing with the ontology of painting, revisiting the whole question of what this can be, the conditions, the proportion, the physical attributes and so on.

L: In this instance you created an engulfing field rather than specific foci.

K: The painting was detailed and dense, so it looked like a very big painting in a small space. Thus it required a certain kind of exploratory attention from viewers.

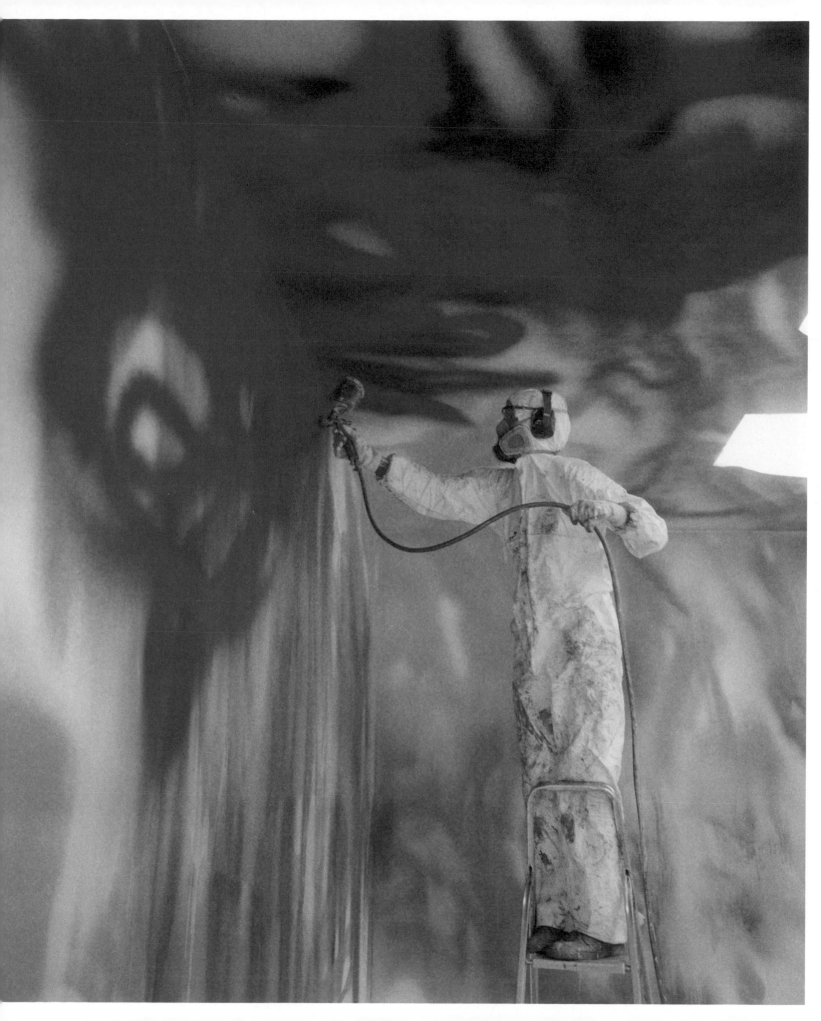

L: Generally your wall paintings are not objectified or bounded. They can function as décor or scenography, as well as a subject, as background and foreground.

K: Painting is the only medium that allows you a panoptical structure with regard to the gaze and a synoptic structure with regard to time. Spray painting intensifies these physiological experiences. It's difficult to say what one really sees and I don't spend time defining my work to other people. Instead I describe the activity itself, or the things I like about the space in which it takes place. In this case, there was a lot of interference: the door, the windows, the stairwell, and the context of the Chapman brothers' jokey "museological" show downstairs.

L: Rather than obscuring the architectural features, you allowed them to punch geometrical forms out of the painting from within, and frame glimpses of the work from the exterior of the building; in a context that could have been restrictive, you structured the painting so that the viewers were drawn into it from far away and moved in and through its different spaces.

You said that you recently saw a Sol LeWitt wall piece being made. There would be little to compare with your work, except perhaps some notions regarding context and instruction. In LeWitt's work, little is left to chance; other people make it, following his instruction. Whereas you make your own work and circumstantial elements are important to your process.

K: It's true that I'm the only one who is visible in my process, but recently I have experienced the importance of team effort in the larger commissions and how it contributes to the final outcome. Now I think I could incorporate other people's decisions into my own but unlike LeWitt, I would never make my process of decision-making completely transparent.

L: Yet, in making your work, you expose yourself.

K: It's true that I don't rehearse it. It is a transparent process that attests to my presence.

L: So your position is humanistic, subjective even. LeWitt's work exercises a level of objectivity within a clear analytical method. Your work can't be similarly systematised.

K: Well, it can't be copied.

L: Not even by you!

K: But I would say that my work *is* analytical.

L: For yourself?

64

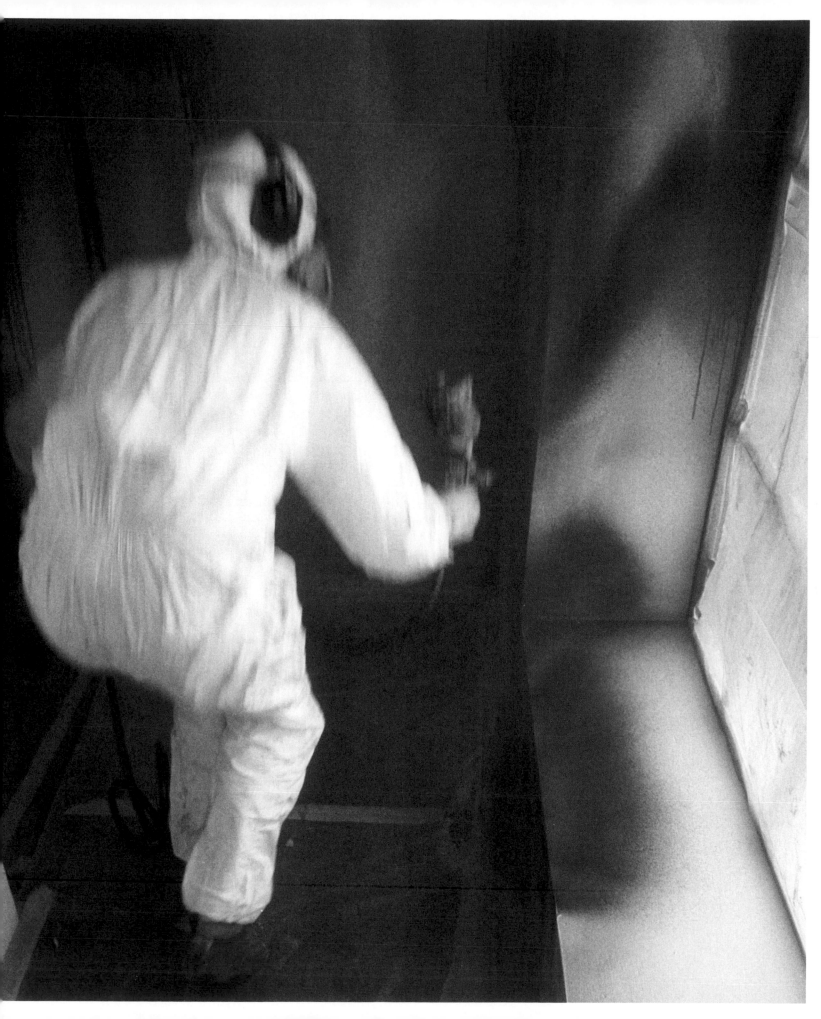

K: The whole working process, every kind of movement that takes place in the space with regard to pictorial thought: In the first phase, I regard the space and what I am in relation to that space, without recourse to a preconceived idea; in the second phase, I take what I have done and refer again to the space containing the first pictorial idea; in the third phase, I take up what I have done and refer again to the space containing the first two pictorial ideas, and so on until I stop.

L: It's a dialogic process then?

K: Yes, with the entire situation, with the pictorial facts that have accumulated. These facts are always visible. That's why I have to stop at a particular point, otherwise these facts could be obscured and the process could suddenly become unclear.

L: What you have described as your working process relates strongly to "structured improvisation" in dance technology, a highly disciplined process that incorporates chance and intuitive elements into its initial codes, a binary system of concept and emotion where one is both the initiator and recipient of the work.

K: Many different things condition my work. That's what I call setting up the tools I work with, which I choose myself, the space included. When I am in this kind of conditioned situation, I develop a secret language that is a chain of intricate decisions. The way I reflect my work is based on previous things that I have done, including things I don't want to repeat. I don't think the split between emotions and intellect exists when I am working and reacting to something I have already done. I am completely aware of what I am doing but I don't want to discuss or name it.

L: Talking further about your relationship to historical precedents, I was always interested that you drew equally from so many cultural areas. Clearly you didn't position yourself squarely in a classical precedent. You gave equal importance to your fugitive, unwitnessed activities.

K: I wouldn't do this now.

L: Yes, but this dichotomy was your formation.

K: I don't have prejudices about expressive forms. Over the last fifty years, painters worked to declare their intentions. Painting is a fast medium, especially the way I work. It doesn't have to be translated; it can transport ideas directly. It can absorb an amazing input of knowledge that creates its own necessities. A painting can be changed in no time. Speed relies on how flexible you are with your own rules; it is directly linked with one's mental capacities. Painting is also a fantastically old medium. Its history is not a burden for me at all because I can use it all. That's why painting is still so fertile for me.

L: Like the inexhaustible potential of the human body. You called cave paintings "the first spray paintings", which evokes for me the notion of archaeological layering in relation to your own work. Your painting for Inside the White Cube is no longer visible, but it is still there, buried under various coats of white paint. So, although we speak about your work as being ephemeral, in fact it is indelible.

K: This paradox between "ephemeral" and "permanent" is not something that I experience. The sense of temporality is obviously very different for me than the viewer in this respect. Each work contains all the other works I have done because I always start with nothing and end up at a point where I don't know what else to do. The period of highest tension for me can be the time between finishing one work and starting another, when I am not communicating.

L: When you say you start with "nothing", you're really starting with everything.

K: Sometimes I have access to knowledge without even really being aware of it. That's why I think it's important to be very active, to do lots of work, to maintain the flow of thought and activity. As I said, sometimes I can't even determine between works, whether the start of one is the end of the previous one, or whether the end of one is the start of another. The function of time for me is completely different, beginning with the idea of permanence. I don't experience my work in terms of its values.

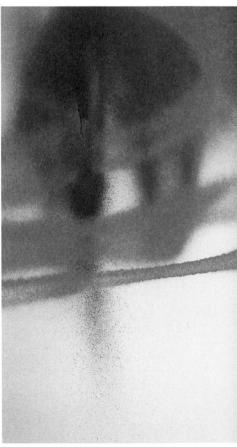

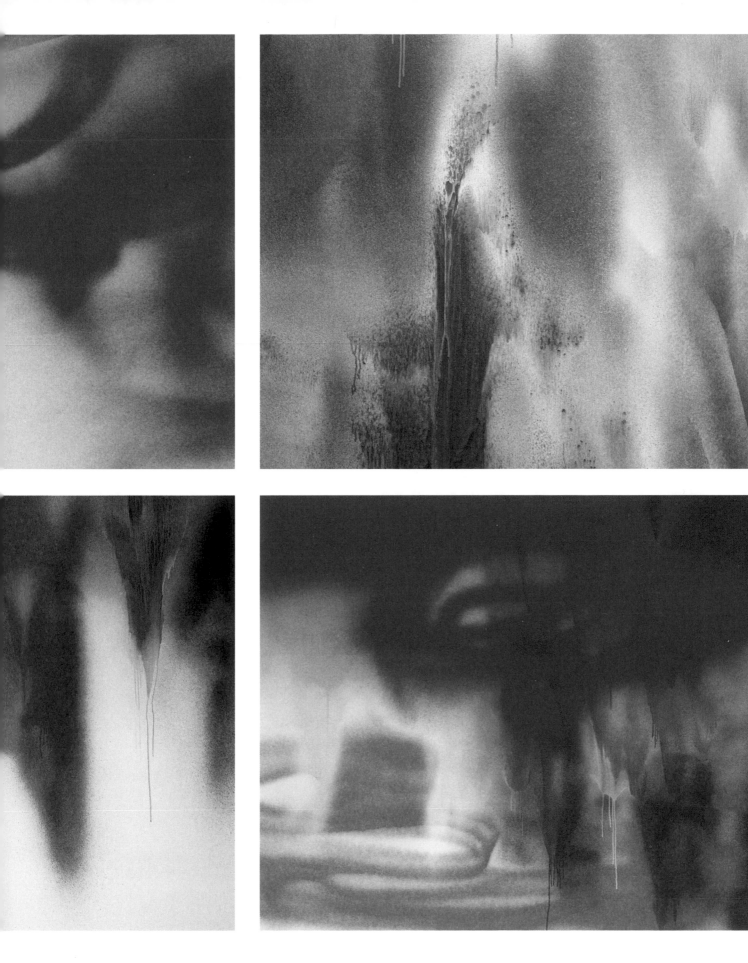

Kas... Ltd.

Bill Number 541 MAIN BILL Date 22/11 Page No. 01

First Contact —
Recommendation LX - Paris
Tailor Work ☐
Special Inquiry ☒
 Material WOOD
 Type WINGS
 Military
 Purpose ☐

Clientcode 701 X X KA
Agent Mr. Galli

Introductory Course necessary ☒
Adaptation Date —
Delivery through Entrance No. 8

Equipment	Description	Charge	Credit	Balance
Wings	Non-members Rate	12.500		12.500
Handbook	Members Rate	5.500		18.000
	TOTAL	18.000	0.000	18.000

TOTAL SUBJECT TO VAT 15.319
TOTAL VAT 2.681
TOTAL ZERO RATE / EXEMPT 0.000

TOTAL INVOICE 18.000

35 Hoxton Square ~ London N1 6NN
Tel: 020-7738-6229 ~ Fax: 020-7728-0907
Mobile: 07936 251 850

DANIEL ROTH

701XXKA

Exhibit A

And several times, said Austerlitz, birds which had lost their way in the library forest flew into the mirror images of the trees in the reading room windows, and fell lifeless to the ground. Sitting at my place in the reading room, said Austerlitz, I thought at length about the way in which such unforeseen accidents, the fall of a single creature to its death when diverted from its natural path, or the recurrent symptoms of paralysis affecting the electronic data retrieval system, relate to the Cartesian overall plan of the Bibliothèque Nationale, and I came to the conclusion that in any project we design and develop, the size and degree of complexity of the information and control systems inscribed in it are the crucial factors, so that the all-embracing and absolute perfection of the concept can in practice coincide, indeed ultimately must coincide, with its chronic dysfunction and constitutional instability.
- W.G Sebald

Towards the end of W.G. Sebald's extraordinary novel *Austerlitz*, the book's eponymous hero sits in the reading room of the newly erected Bibliothèque Nationale in Paris, musing on the meaning of accidental and apparently insignificant events, such as the death of a bird colliding with a skyscraper. To the attentive mind, the novel seems to say that there is no such thing as a mundane event: Every detail, every individual object, every statuette, bird, tablecloth, earring, necktie, every shack on the side of the road, every city street is connected to a wider story, inextricably caught in the movement of a century bent on its own collision course.

An ill-inclined reader might consider this an unduly lengthy excursus, but I believe that Sebald's method, his unfurling of the histories locked away in the muteness of places and objects and in the small black and white photographs he inserts into the body of his own prose, offers an appropriate point of entry into the work of Daniel Roth, an artist also enamored with the incidental and the particular, with the way in which a narrative can string together apparently unconnected places and events into one continuous strip.

Let's start with birds, for example. The bird enjoys a special status with cartographers and urbanists; in contemporary architectural discourse we continually encounter the "bird's eye view", metaphorically associated with a surveying gaze, the apprehension of a whole landscape, a whole situation, in a single take. So Sebald's bird crashing into the transparency of the modernist window, deluded by the promise of open space, provides a beautiful allegory of the self-inflicted demise of rationalist planning. As do Roth's installations: In *The Thermal Bath of the Naked Truth* (2002) the glass curtain walls of the Ford Foundation building, a generic midtown Manhattan skyscraper, veil the Foundation's obscure dealings in genetically manipulated plants that may be used as weapons. While any reader of detective fiction knows that the best way to hide something is to leave it in full view, this logic is absolutely at odds with the ideals of transparency, truth and purity promised by the modernist design of the Ford Foundation building. Elsewhere I have argued that the eerie power of Roth's work lies precisely on the fault line between a rationalist apprehension of space – as exemplified by the promises of modernist architecture – and a paranoid mental attitude – characteristic of the detective, which perceives connections everywhere, and considers everything, especially a

glass window, as the potential screen of some crime or misdemeanour. In fact, as Austerlitz's bird tells us, paranoia is rational thinking pushed to its uncanny extreme; the two positions are only quantitatively, not qualitatively different.

In *701XXKA* (2003) there is a framed photograph of a wall in a tailor's shop located in an unremarkable building on Hoxton Square in London. The photograph contains, among other things, another photograph of an abandoned house, a series of certificates related to the tailor's business, some invoices, and a small door in the wall which, as will be later discovered, contains a secret passage. Near the photograph are a large map-like graphite wall drawing and a framed invoice issued by the tailor for a pair of wooden wings. Rendered in crisp detail, the map traces a route between the different coordinates of the installation's story: the location in London, the house in Poland, a series of underground tunnels through the Alps, and the Palais de Justice in Brussels.

At the bottom of the drawing, the lines connecting the various locations trail off into ribbon-like decorative flourishes. They seem to literally be leaving space open for possible revisions or as yet unmade connections to emerge. This is more than just a stylistic effect: Roth's work develops from one installation to the next, from one exhibition space to the next; it is never fixed and always fluid. Images, objects and locations that appear in one project often resurface later in a different work, like extra clues, buried for the attentive viewer, to the structure of the new tale; and individual projects, although they carry the same title, are very often transformed and adapted from one venue to the next. Like the wall drawings, whose graphite lines on white walls are almost impossible to either photograph or duplicate, Roth's oeuvre seems purposefully designed to eschew reproduction. His installations are site-specific, but almost paradoxically so: they provide the viewer with a particular, irreducible experience, and yet in doing so further destabilise one's apprehension of reality as a solid fact.

Upstairs in the gallery there is a slide projection, which begins with the same house as appeared in the photograph of the tailor's shop, first exterior then interior views, including an image of a chair ominously strapped with duct tape, a knife on the floor, and a map of the Alps. From there the slide projection proceeds, in a kind of narrative ellipsis, to a tunnel entrance at the summit of a glacier, followed by a snowy landscape; some close-ups reveal traces of blood on the snow. After various lapses in the spatial continuum, the progress continues through a mysterious underground passageway into the courtroom of the Palais de Justice in Brussels. As the slide show nears its end, the lights in the gallery automatically fade in for several minutes, revealing various artifacts inside the room in which the viewer is standing: a large wall drawing of a skull with a handwritten fragment of narrative running across it in German, and a small white panel drawing of the interior of a modernist tower block, its windows imploding and scattering fragments of glass across the interior of the room. Both are drawn in Roth's signature style, a kind of futuristic architectural rendering reminiscent of sci-fi or comic-book illustrations. Adjacent is a large vitrine, with a third graphite drawing rendered directly on the support, depicting the outline of a concrete building sprouting ominous root-like tendrils. Above the drawing is fixed a pair of handcrafted wooden wings. These wings are Roth's "Exhibit A", a strangely elegiac version of that detective-story commonplace, the "decisive weapon". Gradually we connect them with the mysterious invoice

no.701XXKA that we saw earlier on the stairs, made by the tailor who carries out "secret orders" alongside his more mundane apparel business. Constructed from bundles of twigs, the wings seem slightly forlorn and fragile, almost incongruously archaic, pertaining more to magic than to utility.

Criminality for Roth is an aura not an identifiable act, a pervasive feeling that leaks everywhere and infects everything, including the space of justice and the law. This is the significance of the Palais de Justice and its Byzantine architecture in *701XXKA*. "The largest accumulation of stone blocks in Europe," it is a dark and dimly lit place, a neo-classical maze of rooms leading nowhere. Where the architecture should serve reason and justice by providing light and transparency, it deals only in shadows, seemingly designed to confound. There, the artist declares, in an ambiguous turn of phrase, "invisible actions are trying to be reconstructed." While this could simply mean that this is the place where the investigation is being conducted, it also seems to imply that the criminal actions somehow also transpire here. In other words, there is no real, qualitative difference between the place where the crime is solved and that where it is plotted; they become interchangeable: "The poetics of crime and its revelation transform the geometrical space of rational detection into a knot of abyssal proportions." In *701XXKA* the bird, usually associated with a clear sense of perspective and the surveying gaze of the cartographer, becomes the locus of the enigma, its dark fetish, through the gothic wooden wings. Indeed, when he describes the installation, Roth suggests that the wings are instrumental in blowing up the tower blocks, as depicted in the illustrated panel.

In his essay "X Marks the Spot: The Exhaustion of Space at the Scene of the Crime," Anthony Vidler notes that if "objects can be presented in the courtroom (...), spaces always have to be imagined, and represented." I would argue that the true subject of Roth's work is precisely this slippage between tangible objects, clearly localized places and an ambiguous, boundary-dissolving sense of space. His work is never vague; it delights in details and descriptions, evidential photographs, solid sculptures, and minute identifications of particular, named places. These, however, are constantly offset by the psychologically displacing power of a narrative drive riddled with ellipsis. His use of photography, for example, owes much to Eugène Atget, with his haunting images of the streets of Paris. The places in Daniel Roth's photographs are almost always deserted. They emanate a kind of suspended, dreamlike quality, "extremely strange sites where seemingly nothing aroused any interest." There are derelict houses, desolate mountaintops, grisaille-tinted dams, old laundry rooms, unremarkable guesthouses, and empty ship decks. Like Atget, Roth recognizes the suggestive power of emptiness, the way it calls forth a "beyond" in intangible ways, "in the margins, in filigree, in the mind."

I suspect that the melancholy tone that pervades Roth's work, in spite of all its playfulness (moveable sculptures, sliding walls, secret doors), is a response to the smoothness and the blandness of the contemporary landscape. Already in the 1960s, the Situationists were bemoaning the dull order of the modern city, stratified by capital and gridded by urban planning. In the years between then and now, it is evident that this condition has only intensified. In many respects, Roth's work elaborates on a significant artistic tradition, from Atget and the Surrealists who discovered him, to the Situationists' radical experimentations with drift and self-abandonment in urban space,

which sought to counter the deadening effects of capitalism on the modern city with the psychological power of dreams, or even the cathartic terror of nightmares. Like his predecessors, Roth is interested in the uncanny, in the way that the most familiar and boring places can suddenly turn strange and disturbing. But unlike the Surrealists, he seems to have little time for the rupture or shock of the single convulsive image, probably because he belongs to a generation raised on horror movies and entertainment-industry products, so he instinctively understands how thin these strategies have become. Thus his handling of anxiety is subtle, carefully calibrated; it lurks beneath the surface without ever being fully revealed.

The unsettling force of Roth's work lies in the continuous push and pull of the narrative, rather than in any one image. These stories curl in upon themselves, arching back towards an ever elusive event. They resist moving forward rationally. To walk into one of Roth's installations is to enter a space filled with particular places and things, and to see a myriad of possible connections between them. Poring over the minutiae of a drawing or the precision of a map, you leave the bird's-eye view and enter a forest of details.

Mai-Thu Perret

Endnotes:
[1] "The Paranoid-Critical Method" in *Persönliche Pläne* (Basle: Kunsthalle Basel, 2002), and "The Paranoid-Critical Method: Ford Foundation" in *Ars Viva 02/03-Landschaft-Henrik Håkannsson, Daniel Roth, Amelie von Wulffen* (Berlin: Kulturkreis des Deustchen Wirtschaft im BDI e.V., 2002)
[2] *701XXKA* was conceived for the Inside the White Cube programme. It opened in London in January 2003, then was reinstalled twice, at the Grazer Kunstverein and Unlimited at the Basel art fair. For each venue, the artist adapted the installation, removing some elements (for example, a flag from the Yale Skulls and Bones secret society that appeared in the London slide show) and adding or transforming others (the skull wall drawing of the London installation later became a mountain landscape with a kind of mask or blindfold).
[3] Translation from the German: "The bruises deepened; the blindfold stayed on the whole time.
A few seconds after we passed the fourth pylon, the cable-car slowed down, stopping just before the fifth."
[4] W.G. Sebald, *Austerlitz* (New York: Modern Library, 2001), 29
[5] Daniel Roth, e-mail conversation with the author, May 29, 2003
[6] Anthony Vidler, "X Marks the Spot: The Exhaustion of Space at the Scene of the Crime" in *Scene of the Crime*, ed. Ralph Rugoff (Los Angeles and Cambridge, Mass.: UCLA/Hammer and MIT Press, 1997), 136
[7] Daniel Roth, op.cit.
[8] Vidler, op.cit., 132 (author's emphasis)
[9] Albert Valentin on Atget's photography, in a 1928 article for the French magazine *Variétés*. Quoted by Peter Wollen in his essay "Vectors of Melancholy", in *Scene of the Crime*, 30
[10] Ibid.

enommen. Kurz nach dem vierten Stützpfeiler verlangsamte die Gondel ihre Fahrt. Noch bevor wir den fünften erreicht hatten, hielt die Gondel an.

LOUISE BOURGEOIS

The Personal Effects of a Woman with No Secrets

Topiary, The Art of Improving Nature (detail), 1998
Portfolio of nine etchings: drypoint and aquatint

Untitled, 1990
Orange skin collage sewn on board

Femme Pieu, c.1970
Wax and metal pins

Untitled, 1986
Watercolour, ink, oil, charcoal and pencil on paper

Sutures, 1993
Steel, thread, rubber, needle and enamel pin

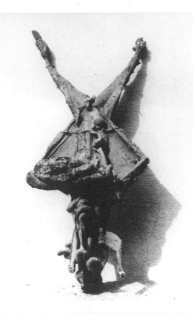

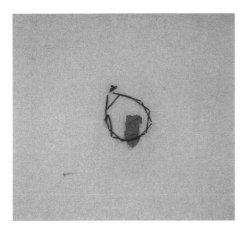

Pink Days and Blue Days, 1997
Steel, fabric, bone and mixed media

Reparation, 1990
Cotton thread and collage on paper

Untitled, 1997
Ink on manuscript paper

Rabbit, 1970
bronze

St. Sebastienne, 1947
Watercolour and pencil on paper

If I am in a positive mood, I'm interested in joining. If I'm in a negative mood, I will cut things.

My childhood has never lost its magic, it has never lost its mystery, and it has never lost its drama. All my work of the last fifty years, all my subjects have found their inspiration in my childhood.
— Louise Bourgeois

Cutting and joining, joining and cutting materials with metaphysics, rational concepts with raw emotions, Louise Bourgeois employs endlessly proliferating formal processes to destroy and rebuild the affective memory that is the source of all symbols and motifs of her artistic language. Her seemingly inexhaustible process of constructed self-revelation leaves in its wake a sculptural and graphic vocabulary of protean breadth and eloquence.

The term "unreconstructed," besides its literal meaning, can infer that something is outmoded or unenlightened. In psychological terms, it suggests a state of mind that resists working through problems so as to be released from habitual patterns of behaviour. Louise Bourgeois's intense, autobiographical writings and the efforts of many recent chroniclers give insight into her unreconstructed affective memory, the hothouse of her formative experiences.[1] Insistently repeated are the stories of her emotionally fraught years in a family of tapestry restorers presided over by a robust, philandering father and a frail, stoic mother; of the duplicitous English tutor Sadie who became her father's lover; of the domestic seamstress who assumed the role of tutor in matters anatomical and sexual amidst the thickening atmosphere of erotic deception that pervaded the Bourgeois household; of the parents who vied for the affections of their talented and sensitive middle child with endless counter-offerings from the houses of French couture; and so on and so on. According to Bourgeois, it is in this period of her fall from innocence that the blueprint of her artistic imagination was formed.

At the beginning of the modern century, Bourgeois underwent a classical French education based on seventeenth-century idealist philosophy with its emphasis on matters both metaphysical and mathematical. At the same time, she received an artistic apprenticeship of sorts in the family tapestry restoration business, developing her natural aptitude for drawing by making cartoons for the missing fragments of damaged tapestries, and observing closely the daily reparations of the artisanal workshop. She then began studying mathematics but soon abandoned the programme, disillusioned and destabilised by the rampant positivist attitude that dominated its intellectual climate (although, no doubt, it was during this time that she encountered Henri Poincaré's principles of topology which were to become so important to her later investigations of continuity in abstract form). Drawn to the possibilities of art in the ferment of the radically subjective early modern era, with movements such as Cubism and Surrealism seeking to construct new ways of ordering reality, Bourgeois undertook her formal studies

in Paris and later in New York, where she moved to in 1938. Though it is evident that her stance is defensive, stemming from a sense of existential solitude so characteristic of the modern period — "For more than fifty years I've been talking about the same subject; so I have a consistency and what I'm interested in and ferociously jealous of is my image — my scribble, the way I see things, the way I express things" — it is also true that she has remained remarkably receptive to and conversant with, at times even prescient of, the concerns and values of her contemporary context: "What modern art means is that you have to keep finding new ways of expressing yourself, to express the problems, that there are no settled ways, no fixed approach. This is a painful situation, and modern art is about this painful situation of having absolutely no way of expressing yourself. This is why modern art will continue, because this condition remains. It is about the hurt of not being able to express yourself properly, to express your intimate relations, your unconscious, to trust the world enough to express yourself directly in it."[2]

Recounting a deeply humiliating incident from her adolescence, Bourgeois demonstrated how making pain physical, (that is, sculptural), can be a way of controlling it: "My father cut the shape of a girl out of a tangerine peel, and then he held it up and said, 'Look everybody, this is Louise. She has nothing! All she's got between her legs is a couple of white threads!' Everybody laughed at me." Her riposte: "Once when we were sitting together at the dining table, I took white bread, mixed it with spit and molded a figure of my father. When the figure was done, I started cutting off the limbs with a knife. I see this as my first sculptural solution." Many decades later, Bourgeois would perform the same, simple gesture of her father's original insult, deftly cutting and twisting an orange peel into a crude anthropomorph — as if by mastering the trick herself, she could, literally and figuratively, cut the insult down to size. In *Orange Episode* (1990, with subsequent versions made) the looming and painful memory has dwindled to a small, dried-out relic resembling one of those bizarre biological specimens so coveted by the erstwhile keepers of *cabinets de curiosités*: "Sculpture allows me to re-experience the past in its objective, realistic proportion. Since the fears of the past were connected with the functions of the body, they reappear through the body. For my sculpture is the body. My body is my sculpture."

In the nineties, Louise Bourgeois began producing a stream of sculptural works directly incorporating her personal effects, which she has assiduously hoarded together with the mnemonic culture of her long life. Her taxonomy begins with Clothes and Belongings, running through Catalysts, Favourite games, Imponderable things, Friends, Enemies, Projects, Arguments one doesn't speak of, Lost objects, What is lacking, Defeats, Home improvements, Infatuations, and so on, up to at least fifty or more categories[3], a bit like the famous "pillow book" of ancient Japanese courtesan Sei-Shonagon. In giving her possessions a second life in her art, she has achieved some of the most daring yet poignant sculptures of her oeuvre, at once hermetic and communicative, fragile and potent. In some instances, she has left the clothing and objects more or less untouched and

arranges them in chambers or on tree-like supports, (*Cells*, *Pink Days and Blue Days*); others she has cut up, or disassembled, and remade into surrealistic phantasms (*Torsos*, *Couples*). With her knowledge of both anatomy and clothing construction, she has expertly sculpted dumb materials (mattress ticking, knitted jersey, sack cloth, flannels, waffled cotton) into startling human surrogates.

A recent series of diminutive yet powerful figurines evoke Bourgeois's "first sculptural solution" with its voodoo connotations, the making and cutting of the bread figure intended to represent her father. Interestingly, voodooists make voodoo dolls not, as is commonly represented, to harm people, but rather to exonerate them from harm, as palliatives or "focusing tools" for positive change. Sticking pins into various parts of the doll's body, then, is intended like acupuncture, to heal, not to destroy. Taking household materials, Bourgeois has cut and joined them into intricate, three-dimensional anatomical forms. Then by fitting these headless, truncated, or dismembered mannequins with whole or partial kitchen utensils (some so old that it is difficult even to imagine what they might have been used for), she gives a startling twist to the familiar folkloric surrogate, reaching forward and backward into history at the same time. With a nod to her Surrealist forbears, Bourgeois's menacing poppets, half-woman half-machine, are cyborg emanations from elsewhere, voodoo dolls for a contemporary generation.

Louise Neri

This essay evolved from an earlier version "The Personal Effects of a Woman with No Secrets", first published in *Louise Bourgeois: Homesickness* (Yokohama: Yokohama Museum of Art, 1997).
A revised version was subsequently published in *Louise Bourgeois: Recent Works* (Bordeaux, Lisbon, Malmo and London: capc Bordeaux, Centro Cultural de Belém, Malmö Konsthall, and Serpentine Gallery, 1998-99)

Endnotes:
[1] The most comprehensive of these to date are by Christiane Meyer-Thoss, *Louise Bourgeois: Designing for the Free Fall* (Zurich: Ammann Verlag, 1992); Jerry Gorovoy and Pandora Tabatabai Asbaghi, *Louise Bourgeois: Pink Days and Blue Days* (Milan: Fondazione Prada, 1997). All statements by Louise Bourgeois appearing in this essay were taken from these two sources unless otherwise indicated.
[2] Donald Kuspit, "An Interview with Louise Bourgeois" in *Bourgeois* (New York: Vintage Books, Elisabeth Avedon Editions, 1988), 82
[3] Bourgeois's list of lists is elaborated in Paulo Herkenhoff, "Louise Bourgeois, Femme Temps", in *Louise Bourgeois: Pink Days and Blue Days*, 255-269

ANDREAS GURSKY

Let's imagine going up in a balloon or an airplane some hundreds of metres above the ground; and the mind, delivered from all it knows of man, tries to see and to record the essential facts of human geography with the same eyes and the same look which allows us to discover and sort out the morphological, topographical, hydrographic traits of the earth's surface. From this hypothetical observatory, what do we see? Or better yet, what are the human facts that a photographic plate could register as well as could the retina of the eye? Central to this expression is the division of the machine eye and the human eye, of the objective and the subjective, in general, part of nineteenth century debates and practices regarding photography and the issue of artistic expression and objective science.

Like Albert Kahn's extraordinary geographical archive, "Les Archives de la Planète" begun in 1909, Andreas Gursky's ongoing photographic interpretation of the contemporary world is exclusively visual. The geography that "Les Archives de la Planète" represents explicitly posed questions of fact and truth, document and significance and linked them to a notion of the visual and geography's photographic practices. These practices were ambiguous: on the one hand, naturalist and positivist, on the other hand, subjective and relativist. Almost one century later, the spectacular and highly controlled otherworldliness of Andreas Gursky's signature style draws on a great diversity of (often antithetical) motives, currents and methods through which the artist has developed a dense, vivid and edgy dialogue between photography and painting, empirical observation and artfulness, high art and commerce, conceptual rigour and spontaneous observation. In consistently fusing the flux of life with the stillness of metaphysical reflection, he has created a *Weltanschauung* or world view that, as viewers, we have the impression of always being outside of looking in: in this fact, we are constantly reminded that what we are looking at is not reality per se, but a reality of the artist's invention.

Andreas Gursky makes very few pictures each year. The process of synthesis happens as much in the artist's mind during a period of reflection and gestation as in the production of the image itself. Intuition and spontaneity — the surprise of a "persuasive image" to the artist's highly receptive eye — are as important to his decision-making as technical rigour and discipline. His processes of research and development, preparation, revision and production for each of the epic moments that make up his wide-ranging oeuvre are usually private, lengthy, and elaborate, often requiring strategic negotiations on a scale befitting their subjects. It is this often imponderable "how" of Gursky's pictures together with the "what" that constitutes the deep mysteriousness and complexity of their visual register. From initially using the computer as a retouching tool, Gursky began to work increasingly with the transformative potential of its fluid capabilities, sometimes fusing elements of several shots of the same subject into a seamless whole and reworking the image pixel by pixel, at other times barely altering the image at all. But in insisting on using the astonishments of reality as his point of departure, he has avoided what Peter Galassi has referred to as the "overwrought outpourings of Surrealist kitsch in

both the commercial and high-art realms," although his process has become increasingly baroque in both its conceptual ambition and structural reach, just as the subjects themselves have expanded and proliferated from his immediate vicinity — the industrial and urban environment of central Germany — to map and distil the emergent patterns and symmetries of the fast-paced world at large. For example, one can enjoy speculating that an early, strangely compelling picture of chickens in a small field that possesses an almost Vermeerian sense of composure, may have at least partly inspired Gursky's latest image, a subdued but no less compelling composition depicting a seemingly infinite geometry of gridded cattleyards dotted with drifting livestock, located in an expanse of empty, unnamed — almost unimaginable — elsewhere.

Louise Neri

The white grid slants away across a flat brown tract of trodden earth. Looking down, we approach it at an angle. The grid tilts toward the horizon, its end marked by winter trees and a river, beyond which the land rises and fades into low hills a long way off, which themselves fade into a pale blue sky.

The more you look the more there is to see - distant silos, a pair of horse riders, the heavy plant of modern industrialised farming — though it is difficult for the eye to settle anywhere for very long: there's too much to look at, too many details in the huge space of the image. We are in a helicopter, looking down on a section of a stockyard, which covers hundreds, if not thousands of acres. The grid is made up of white fences and service roads. The space seems big and empty but it is full of life, the stock pens full of cattle doing the things cattle do. In places the brown, churned up earth has sunk and flooded, leaving small puddles of blue grey water. In each pen the steers and heifers hang around the water trough, stand alone and in groups. A few look upwards as the chopper swings over and German artist Andreas Gursky takes his five-hundredths-of-a-second shot.

Too many cows to count, though the camera sees them all. The detail is so crisp you can see ear tags, if not the whites of their eyes. In one of the nearer pens all the cattle appear to be black, and elsewhere they're a variegated mix, cows the colour of the earth itself and white Holsteins. Rounded up and sorted in their holding pens, they await the northward drive towards Chicago, where they'll be sorted again in other pens and sold and killed and chopped up into bigger and smaller pieces, sorted again and sold on, where they'll be forwarded to wholesalers, hung in freezers, off to the packers and then on to trade distributors and retailers. The passage from on-the-hoof live flesh to sides and steaks, from ribs to burgers and canned consommé, all takes place in an even larger grid, a processing network that ends, if you think about it, not even in the subterranean sewer systems under our modern gridded cities.

The stockyard is but one more way station in this process of ordering and separation, but one where we still, unavoidably, think about all the shit and urine these animals produce, and where the manure ends up; in the ground-water, in the river. But at this point we can still look down, along with the photographer from Düsseldorf, homing in on a live, ruminant, uncomprehending animal looking up at the racketting blob passing over against the empty sky.

These are not Constable cows or Cuyp's, nor yet the bloody hanging carcasses of Rembrandt or Soutine. This is *Rawhide* gone industrial, without a hint of pork'n'beans and trail coffee, an industrialised west where even the Marlboro men have quit. The grid itself — on the tilt, a bit irregular, a thing of fence-posts and roads and numbered gates — is already emblematic of a mentality. Grids are practical. They bring together and they divide. They impose themselves on the world, carrying with them a sense of order, of coordinates, of regularity. In Rosalind Krauss's great 1978 essay on the subject of the grid, she talks about the ubiquity of the grid, of its being both a sign of our materialist view of

the world, and its almost spiritual, other dimension in much art, from Mondrian to Agnes Martin, Sol LeWitt to Eva Hesse.

The stockyards of Greeley, Colorado, also occupy a kind of double space on the plains in the American West—both a frontier to a mythic and sublime, and largely vanished wild, and a place where land has been parcelled-out, flattened, tamed. The large photograph itself, the image with its all-seeing, panopticon eye, is itself not just the result of the blink of the cyclopean shutter, but has been digitalised, reordered, its own space reapportioned through the grids of a computer programme. The more you think about it, the more vertiginous the world gets, the more the image itself appears as just a few squares on a grid which is endless, and in which the human subject is shrinking and receding into the infinitesimal. A cow looks up at the 'copter, we look out on the image. The real vanishing point is where our incomprehension meets.

There are only two images in Gursky's show in the small upstairs space at White Cube. Gursky's *Greeley* — at 210 by 260 cm, a very large image — is complimented by a pair of small photographs of the interior of a supermarket, the rows of packed shelves receding towards the back wall. Looking out onto the vastness of *Greeley* and looking into the packed aisles of canned, packaged, processed goods under the strip lights may be to state the obvious about consumer society, but the more you think about it the more meanings and readings present themselves.

These are not documentary photographs. They are not evidence. There is not, even, a critique embedded in them, except to say that we are what we look at, as much as what we eat. And asking why we might want to look at these images might be the most interesting question of all.

Adrian Searle

A version of this essay was published in *The Guardian* March 11, 2003.

TRISHA BROWN

It´s a Draw

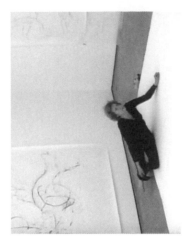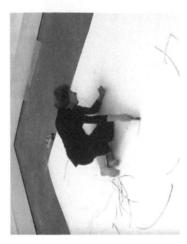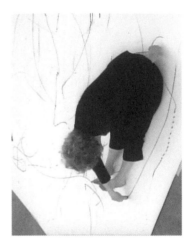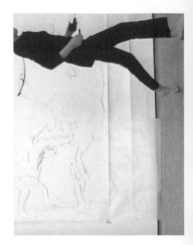
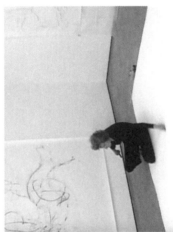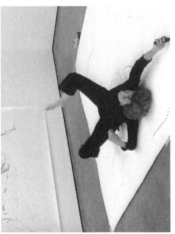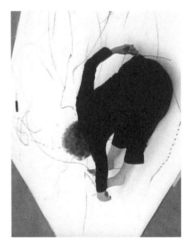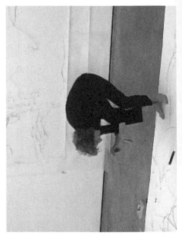
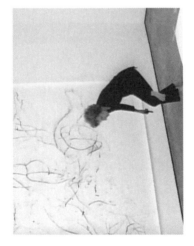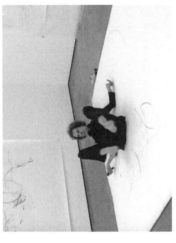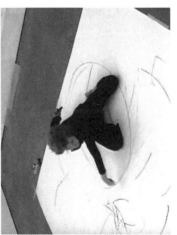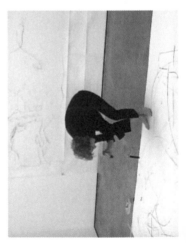
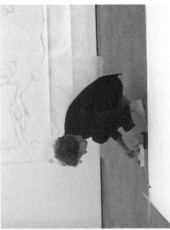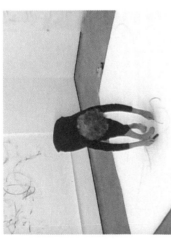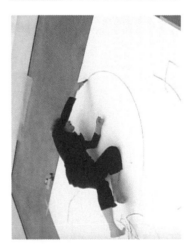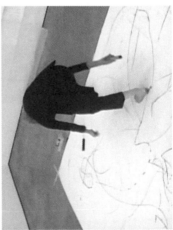

|Trisha Brown's Emotional Geography

I'm alone with Trisha Brown in a gallery space that measures six by seven metres, watching her move around on a huge sheet of paper fixed to the floor, sticks of charcoal and pastel gripped in her hands and feet. She wears slim, matte black, making a visual corollary with the elementary drawing tools she employs. She works swiftly, absorbed in inscribing the flows and fluctuations of every moment within a larger, unseen design of time and space. Her body releases itself against the paper in a seemingly endless possibility of expression, from generous sweeps and loops to terse curls and strikes. Sometimes she utters intelligible words; at others strange, powerful sounds well up from somewhere deep inside her, expressed as voice. This goes on for quite some time until suddenly, she steps out of the paper, as quickly as she had entered. She walks around its edge in order to decide its final orientation, then signals for it to be raised carefully from the floor in a single, deft action and fixed simply to the wall. Only then does she really see her drawing for the first time.

After an interval, she will begin again, another sheet of paper, an entirely different experience, a new event.

People who are not professional dancers understand choreography as the aesthetic instruction that underpins a live dance performance rather than the actual idea of writing itself. (Although, interestingly, écriture is the term that choreographers actually use to describe a personal movement vocabulary; it harks from the illustrated French dance manuals of the eighteenth century where the figures of court dance were first recorded in systematic graphic form.) But by using movement to generate graphic works and drawing to catalyse that movement, Brown, a virtuoso performer and iconoclastic figure in the related spheres of dance and art, has given this linguistic term new and expanded meaning in both the physical and graphic worlds.

Brown's trace materialises movement's pulse without otherwise consigning to it a form; thus the commonly accepted notion of dance as possessing a magic that is by nature ephemeral and self-effacing begins to falter, just as certain assumptions about notation begin to lose definition. This kind of action-drawing confounds and embodies the instants of two simultaneous projections of the self, in two and three dimensions. Although a certain majestic solemnity pervades the finished drawings, Brown's studied nonchalance – which emerges from her unique perception of movement that legendary contact improviser Steve Paxton once described as "wild, something that lived in the air"[1] – toys with the evidence of her very presence and works to debunk her own mythic stature.

Brown's earlier drawings were notational in scale and ambition, sketchpad size, featuring closed representational forms or geometrical compositions. By contrast, her new drawings record directly the

111

full expressive reach of her own body. In the sixties and early seventies, she staged one-off events in urban settings such as rooftops and facades of large buildings, parking lots and city streets so that incidental quotidian elements became part of her work's ambit. At the same time, she performed experimental works in galleries and museums that tested the viewer's perceptions about his or her own physical and psychic bearing relative to what they were seeing and experiencing, just as the conceptual art of the time played on the viewer's relationship to the art object. Taking her newly developed knowledge into staged space, she radically changed its organisation, often placing principal choreography at the stage margins or facing dancers backstage. Her approach to the body was similarly decentralised; she reinvented it as a field of equal places with varying centres so that it became possible to initiate action from any place at any time. In the eighties, more complex ideas of cyclic dramaturgical structure entered her repertoire, reaching efflorescence in her embrace of baroque opera and fugue in the nineties and the new century.

When she began making the large drawings, Brown was working on the development of *El Trilogy* (1999–2000), a dance work in five parts, including two interludes in which the mechanisms of stage culture are revealed alongside danced solos. With inspirations as diverse as the weather and the breakaway routines of Leon James (a famous Lindy Hopper of the Harlem Renaissance) *El Trilogy* culminates in a final phase of unprecedented baroque complexity. Graphic backdrops conceived by artist Terry Winters bracket the five parts, underscoring the sustained dynamic tension of Brown's work with images in which mathematical precision intersects with irrational exuberance.

Breaking with her normal methods of delivering dance to her dancers, Brown developed the basic phrases for *El Trilogy* alone, in a flurry of solo improvisations. During our conversation for this essay, she said that at the time she had been listening to a percussive score by jazz composer Dave Douglas (who also wrote the music) because "percussion is neutral and it is a grid"; later in the same conversation, however, she also claimed to have been absorbed in the highly emotive score of Schubert's song cycle *Die Winterreise*, which she had recently been invited to stage. What might appear at first to be an inconsistency in Brown's recollection of how things actually happened, in fact, attests to the pervasiveness of oppositional strategies in her method, this time the influence of contradictory musical forms on her working imagination. Once again she reveals herself to be working within the baroque dichotomy of geometry and emotion.

The large drawings correspond to Brown's grander projects, the paper mushrooming into the environmental scale of the studio or stage so that the fields of performance and drawing become more closely integrated. In this expanded graphic field, she is able to map the entire scope and passage of her movement — and thus the workings of her mind—in actual size rather than reducing it to notational form. And once on the wall, the drawings, not framed or flattened or otherwise contained, seem to continue

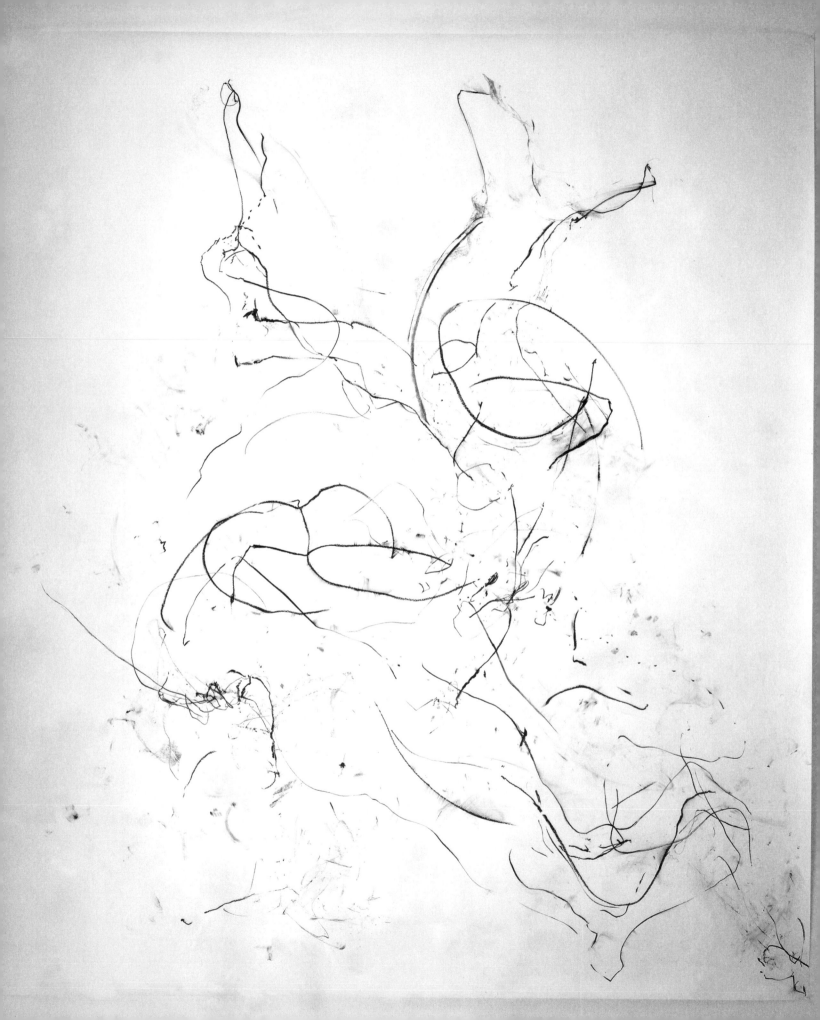

their expanding action beyond the boundaries of the paper itself, invoking a space and time that are much greater than what we see, which belong – like the trace that the performer leaves in the air when she quits the stage – to the realms of eidetic function.

What is particularly striking about witnessing Trisha Brown at work is that every drawing she makes is quite different from those that precede it. Each has its own specific generative set of instructions to which she adheres, while paying acute attention to the stimuli "splattering all around" her. The emergence in each case of open and closed systems and forms is fascinating: one looks like a classic choreographical notation, all small figures and tight, energetic strokes skittering over the paper (*Untitled III*, 2003); another is patterned with columns of linear Rorschach-like forms (*Untitled IV*, 2003); others such as *Untitled II* (2003), produce the broad undulations and sequential movements for which her "liquid" body is famous; the final drawing of the London series (*Untitled VI*, 2003) begins with the curve of her graceful, lounging body traced by hand at one edge of the paper and ends towards the centre in a struggle of deeply etched lateral marks made by dragging her feet.

At this point I must refer to "structured improvisation," the compositional strategy that Brown developed in the sixties with *Trillium, Lightfall,* and *Rulegames,* and elaborated in the seventies with *Accumulation, Locus,* and *Sololos.* For Brown, the body is a mnemonic instrument; through decades of choreographic questioning and advanced physical studies, she has proved that its muscles and bones store memories that can be brought back either through repetitive movements that function as cues, or through improvisatory techniques that allow past experiences to surface spontaneously and abstractly. "Sometimes my actions are purely emotional strikes at the paper, and the minute that that aggression flies out of me, I know what the figure is; from there I move into a process of repetition and reiteration and oppositional strategies."

This experience that Brown recalls so vividly as her improvisational process evokes fugue, a key baroque musical proposition that Glenn Gould also described as being as ancient and mysterious as the human pulse. Like Brown's process, fugue can have multiple, even contradictory guises: as a compositional structure that invites invention according to an invisible cue, resulting in the infinite permutations and variations of counterpoint; as escape; and, finally, as a lapse of consciousness from the external world. Perhaps this last guise, belonging to psychiatric terminology, is especially relevant to understanding how Brown "is" in the drawing. "When you are improvising, there is a way that you dispatch the mind, you send it away. The same kind of thing happens to me when I am drawing. The gestures are transferred to paper. I couldn't make that line any other way. And yet, there is this compositional mind that comes from dance, that is informed dimensionally, and that directs me when I am drawing." Evidently, the same oppositional strategies that bring the necessary tension to the performance are used to achieve the delicate balance of form that materialises on the paper.

114

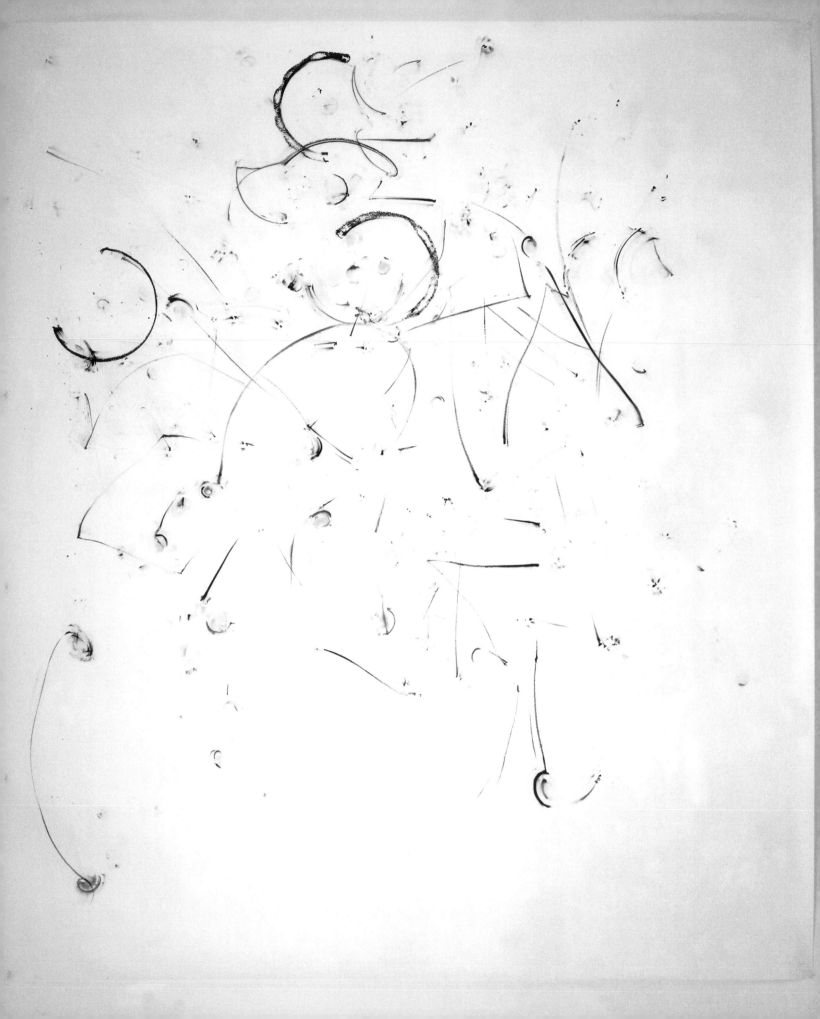

After completing the final drawing of the London session (*Untitled VI*), Brown was momentarily overcome by the revelation that the charcoal drag-marks she had made with her feet were recollected memories of her mother, who suffered the effects of polio. Given what has just been said about stored somatic memory, it is perhaps no coincidence that this reaction echoes an account she gave to Yvonne Rainer in 1979 of the historic *Accumulation with Talking* (1973) — a lecture combined with fixed choreography — in which she commented, "While doing it I said, 'My father died in between the making of this move and that move,' which knocked me out. I was amazed that my body had stored this memory in the movement pattern... I became silent and composed myself. I was devastated that I had said that."[2] More than twenty years later, Rainer observes that Brown's movement, in its rootedness in idiosyncratic personal/physical history, its detachment from musical and narrative cues, and its refusal to conflate emotional expressivity with recognisable mimesis, has pushed her toward a total rewriting of the terms of choreographic expression and its previous manifestations.[3]

Years ago, I talked with Trisha Brown about Paul Carter, an Australian spatial theorist who broke ground with his reimaginings of exploration history, based on close readings of the journals of eighteenth century frontiersmen.[4] At the time, I was using Carter's revelatory distinction between discovery and exploration as a metaphor for artistic investigation. According to Carter's theory, "discovering" is the constant revisiting or territorializing of a strange place in terms of what is already known, whereas "exploring" suggests the more challenging and imaginative trajectory of no return. In these terms then, Brown's choreography, predicated on her own private methods of structural improvisation yet alert and susceptible to all manner of external and foreign stimuli, is a series of ongoing exploratory events. Although these events may be related, she can never revisit the exact same site again.

In Carter's detailed study, explorers were revealed, via first-hand accounts, grappling with the strangers inside themselves as they were subjected to extreme or unfamiliar conditions. Evidently, the intensity of the unknown made them open to extraordinarily liberating insights but also extremely prone to various kinds of debilitating psychosis. In contrast, I perceived that artists, by understanding the presence of the stranger inside themselves as an immanent condition, are able to create dynamic, performative contexts through which to explore and confront this same feeling. Rather than suppressing the innate contradictions within themselves, they exonerate them as the active and fertile ideas we call "art". Brown concludes, "The transition from improvisation (you'll never see that again) to choreography (a dance form that can be precisely repeated) requires great effort and not formula, the ideas take a visual presence that I am self-taught. If one is working with form and not formula, the ideas take a visual presence in the mind and one must find a method to decant that vision".[5]

The Ionians, the first known philosophers, were physical geographers. A surviving philosophical fragment from that period (no doubt wisdom abstracted from cartographical process) maintains that in order to

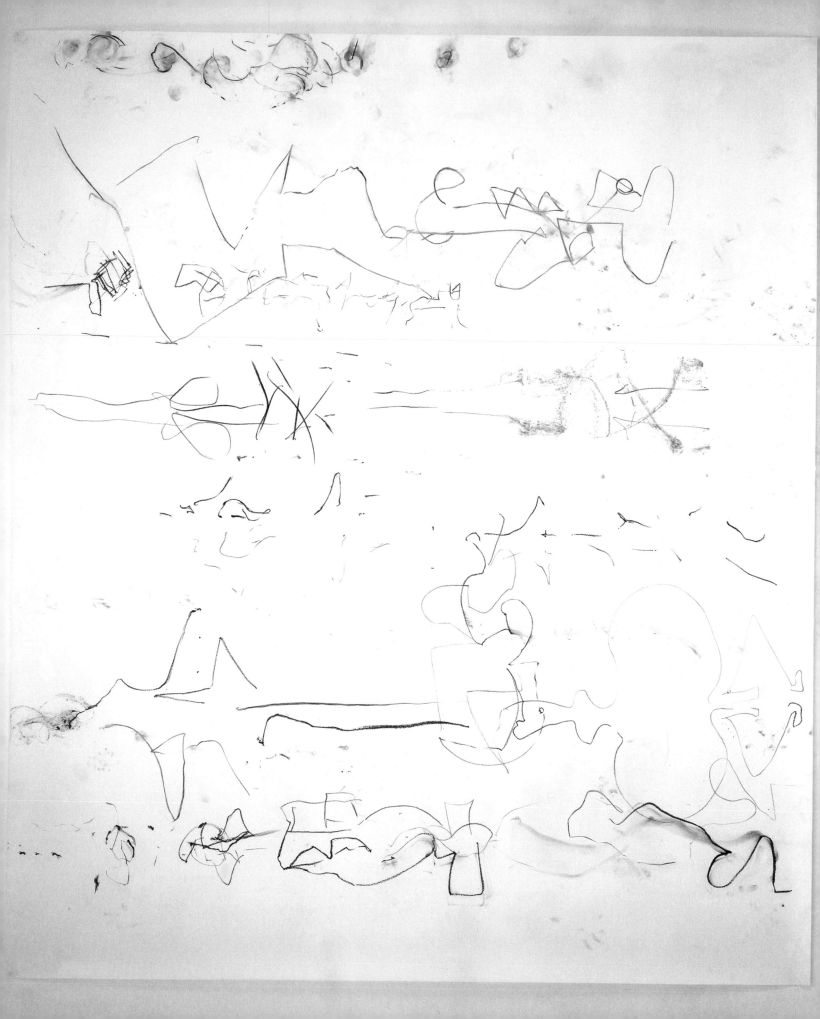

know who you are you have to know where you are. In exploring the body in motion as an exponential source of intelligent expression, Trisha Brown continues to incorporate new physical concepts and experiences and ever more intricate cultural influences to feed her conception of the active and emancipated self. Guided by this ever-accumulating knowledge, her choreography — both performance and drawing — keeps moving into previously unimagined zones, showing the "concrete mystery" 6 of the body to indeed be both the place and the space of identity. "There is an edginess to this process for me. This is me; my identity is fluctuating all the time. Perhaps it is this fact that allows me to make marks I have never seen before. This is what I love about drawing, that the quality of the markings on the paper can be so astonishing; they are like visitations on the paper, moving from dustiness to dark, terse inscription and then a sudden smudge. It's an amazing evolution of gesture."

Louise Neri

Unless otherwise stated, all quotes by Trisha Brown are taken from a conversation with the author in June 2003. The author's essay also borrows from Trisha Brown: Dance and Art in Dialogue, 1961-2001, a superb monograph published by the Addison Gallery of American Art and Phillips Academy in 2002 to accompany a travelling exhibition, touring the U.S. in 2003. Both were conceived and directed by Hendel Teicher.

Endnotes:

[1] Maurice Berger, "Gravity's Rainbow", *Trisha Brown: Dance and Art in Dialogue 1961-2001* (Andover, Mass: Addison Gallery of American Art/Phillips Academy, 2002), p.23. Quote by Steve Paxton is from Sally Banes, *Democracy's Body: Judson Dance Theater 1962-64*, 121

[2] Yvonne Rainer and Trisha Brown, "A Conversation about Glacial Decoy", *October 10*, 1979, 34
In *Accumulation with Talking* (1973) Brown was still working with a fixed instruction, as in the original *Accumulation* (1971), this fixed structure evolved into an open form with the accumulation as infrastructure.

[3] Yvonne Rainer, "A Fond Memoir with Sundry Reflections on a Friend and her Art", *Trisha Brown*, 52

[4] Paul Carter, *The Road to Botany Bay: An Exploration of Landscape and History* (Chicago: University of Chicago Press, 1989)

[5] Trisha Brown, "How to make a modern dance when the sky's the limit", *Trisha Brown*, 290

[6] Trisha Brown, "A Concrete Mystery", (published as "Un mystere concret"), *Le Bulletin 5*, 1990

118

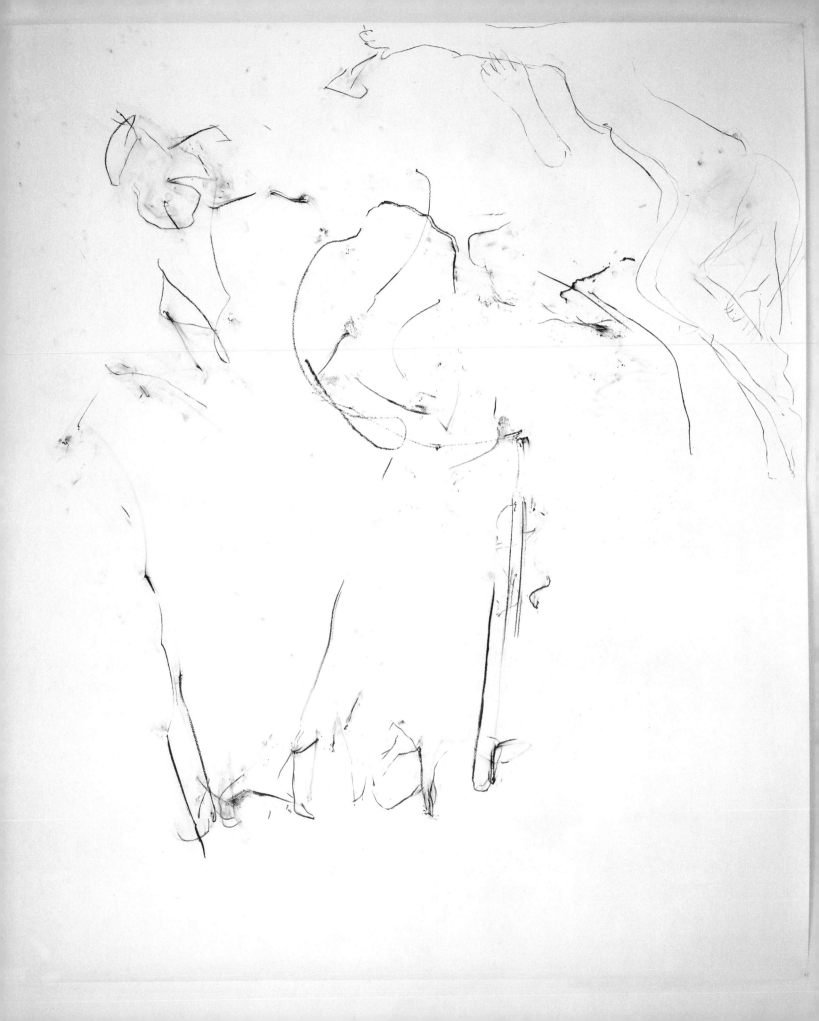

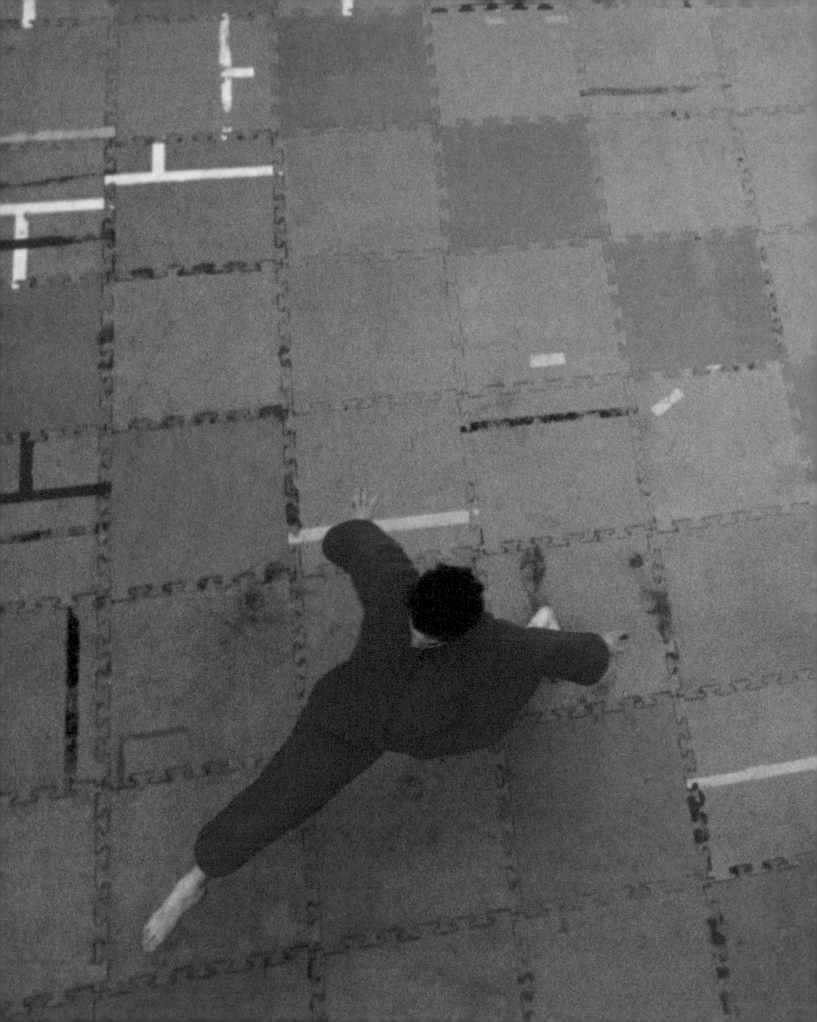

BORIS CHARMATZ, DIMITRI CHAMBLAS, JULIA CIMA, CÉSAR VAYSSIÉ

Dance in the Unlimited Field*

In 1933, the Dutch historian, Johan Huizinga gave an oration at the University of Leyden on "the Cultural Limits of Play and the Serious," in which he enunciated an original conception of play as free activity, delimited within a "sacred" area, and thus separated from ordinary life.[1] At this time, most probably without Huizinga being aware of it, Europe was experiencing a ferment of unprecedented dance activity inspired by game-playing and sports, as exemplified in the choreographies of Albrecht Knust, Rudolf Laban and The New Dance Group.

In response to Huizinga's discovery, philosopher Roger Caillois produced a remarkable sociological study entitled Man, Play and Games (1958), whose intention was much more than to merely map a sociology of games; it would, he claimed, attempt to lay the foundations for a sociology derived from games. Defining play as a "total activity", at once liberty and invention, fantasy and discipline, he reintroduced its central importance in the stimulating of consciousness and cultural manifestation. "The spirit of play" he wrote, "is the source of the fertile conventions that permit the evolution of culture," creating and respecting the nature of inquiry, respect for rules and detachment.[2]

Caillois observed, perhaps too flippantly, that "Play and art are born of a surplus of vital energy, not needed by the adult or child for the satisfaction of his immediate needs and therefore available for the free and pleasant transformation into dancing."[3] Nevertheless, by linking play and dance in a single sentence, he had touched on an entirely new ontology of social and artistic relations. Within a few years of this intellectual breakthrough, on another continent, young dancers Trisha Brown and Steve Paxton, working in the challenging context of the Judson Dance Theater collective (an essential group in the postmodern dance movement), Fluxus and Happenings, combined revolutionary kinaesthetic knowledge with physical virtuosity to invent new movement paradigms — structured revolutionary improvisation (Brown) and contact improvisation (Paxton) — through which to explore their own ideas and perceptions of play as a communication model.

Today, Boris Charmatz and the vibrant dance community in which he plays a key part, are actively exploring and recontextualising the ideas and methods of their innovative predecessors in an attempt to lay the foundations for a new sociology derived from dance. In 1992, with fellow dancer and choreographer Dimitri Chamblas, Charmatz founded Association Edna, accompanying their first choreographical works. Now ten years in existence, Association Edna with its expanding network of artistic associates, thrives as a vital, independent creative entity, developing and coordinating diverse choreographical activities and multifaceted experiments in the performative field in order to provide tools to look at choreographical culture with new eyes. This research assumes various forms: thematic sessions aimed at a multiplicitous approach to dance and the body, film production,

exhibitions, and the creation of settings for critical reflection on art and its practices. Combining a vast working knowledge of their chosen field and its related physical and philosophical disciplines with an extreme political astuteness with regard to negotiating resources for their diverse creative needs, their conception of the active, emancipated body as a source of human potential seeks to reinstate dance, one of the most ancient forms of human expression, at the centre of a contemporary culture currently at risk of losing all relation to self.

At the time of writing, Association Edna's project, "Entraînements", was in progress, a series of events designed to open up various urban locations for transitory situations in which the experience of performance — the individual practices and rituals that performers invent — and everyday life intersect.[4] For example, a series of spontaneous choreographical improvisations — "confrontations" — was conducted by these roving modern-day Situationists in uninitiated sites including state offices, libraries, and a hostel for women and their children. The sites were not publicly disclosed, making clear that audience for these events, beyond the participants from the sites themselves, was not desired. Descriptions of the events by witnesses and participants ranged from touching to disturbing to outright hilarious, attesting to the potential power of dance to subvert and transcend, using whatever means at its disposal, the mental and physical strictures of the modern city's rationalist grid.

Earlier this year, the Centre National de la Danse published Entretenir/à propos d'une danse contemporaine, a conversation in many parts by Charmatz and dance historian Isabelle Launay.[5] Expounding freely on a dizzying array of motives and themes, nouns, verbs and adjectives that describes their conception of contemporary dance — these include ironie, terrier (to burrow), éclectisme versus hétérogène, buggle (a wind instrument) — the authors have compiled an impassioned call for renewed value and responsibility in artistic practices, enlisting as they go, by way of brief and instructive citation, a ballast of influential figures of the international avant garde. Among the fifty-three entries is école, containing ten propositions for a school of dance: In his capacity as a creative research fellow at the Centre National de la Danse, and with the collaboration of specific dance organisations in Europe, Charmatz is now developing a nomadic and provisional school called BOCAL. The word means glass jar or bowl, alluding to the intensive, collective nature of the enterprise and, perhaps, the public attention that such pedagogical iconoclasm will bound to attract.

Rules of the Game:

In Man, Play and Games, Roger Caillois distinguishes several categories within the status of play, itself comprising the interdependently functioning values of padaia (basic freedom) and ludus (transformative rules): "The game occurs within agreed boundaries; the same is true for time; the game

 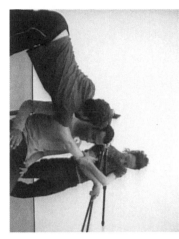

 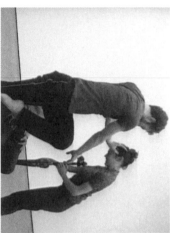

 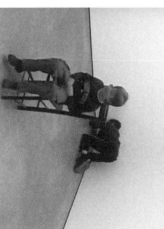

Some (unofficially) translated excerpts from *Entretenir/à propos d'une danse contemporaine*

From *ironie:*

My irony is as much to do with doubting as acting. This doubt isn't sad. It doesn't arise from an attitude that is mocking, distant, cynical, or nihilistic. Rather it comes from a broken contract of confidence regarding what is now evident in performance, art or teaching. This irony is not a manifesto, nor is it directly manifested. Today's ironists are, above all, sceptics. They plant bean seeds on sheet metal, knowing full well that nothing can grow there, except the rust produced by their own sweat. They plant with great application however, under the spotlights, because it is their way of doubting that contact with the earth can ferment a sense of liberation that dance has often sought. They plant because these enigmatic seeds of movement check their own seriousness. They keep planting to establish an incongruous link between the peasants' earth (that is worked), the walkers' earth (that is received), and the compost-earth of artistic research (that the dancers of the twenties trod; the American, Greek, Indian or German earth that the Japanese dancers swallowed so as to fully assimilate it). They no longer ask themselves whether or not such a gesture guarantees liberty or expression of a subject; rather they wonder what it is exactly that one desires at any price to liberate oneself.

From *soupçon:*

So what are dancers looking for, by repeating, to the point of exhaustion, falls, stretches, grips, jumps, rolls, by activating, not without struggle, wherever they can?

Identities can be seen vacillating on today's stages; signs no longer seem to cover the objects that they allegedly designate, just as discourses are no longer on the pulse of what is actually brewing. Just because you dance nude doesn't mean that you are freed from as many conventions of sociability and power relations. Just because you leave the theatre doesn't mean that you no longer submit to its rules of conduct, or that being there, you are necessarily submitted to them. Just because you make an exhibition, a performance, a journey to the place of a spectacle doesn't mean that you are, in essence, more "critical." There is no longer a door that guarantees you an exit. Whatever the operative choices of a project, it is only in the modalities of your on-scene presence, the manner in which you conduct a process or transmission, that you can define your access into a particular context that is your own.

Suspicion is productive, as is welcome the floating and boredom that sometimes accompanies it. This suspicion can be a pressure that encourages you to unbutton yourself. Transgressing, subverting, disobeying are rare acts, hence our taste for the so-called historical avant garde of the twenties and thirties and the sixties and seventies.

But the support that gave these acts meaning is no longer defined with the same clarity as then. If we were being pessimistic, we would say that there is nothing left to do today except reaffirm paternal law, reinstate the law, monumental history, and choreographic patrimony, reestablish the lineage so that transgression can make meaning. But the absence of these symbolic guarantees is, from now on, the chosen artistic scaffolding. It does not destroy the competence of the spectacle or the desire to attempt real adventures in the field of dance. To the contrary, it provides emergency exits, as does sceptical vision for the forms that can take on the spectacle, coupled with a real conviction that we can mobilise forces, grab the real, take up things, risk part of our status, see our identities in terms of a project that is greater than its players. This desire dominates pervading disillusion. Even if we no longer share the ideology of our parents, we have retained their militant spirit. This impulse inhabits us, even if we don't carry flags. It would lose all sense if it congealed. Doubt is a riddle that filters the surface of events so that what we do can be a bit more refined than the retinues of power.

Let us then try to invent new organisations for the production of meanings, without seeking to totally master them, explosive cocktails of varying size. Meanings, the movement of signs, are finally what is there when a dancer is on the stage; the artist is no more capable of talking about it than anyone else. Meanings form a jungle that each finds a way through, anyway he can.

starts and ends at a given signal. Its duration is often fixed in advance. It is improper to abandon or interrupt the game without a major reason. In every case, the game's domain is therefore a restricted, closed, protected universe "a pure space."[6]

Inside the white cube, the windows blocked out to create a tight and airless chamber, Boris Charmatz and Julia Cima worked spontaneously with members of the public to evince attitudes of active and passive performance through variations on contact improvisation, or to be more precise, contact improvisation without contact. In this improvisation that they named *danse suggérée*, or suggested dance, a person simply sits on a chair in the middle of the room, eyes closed, completely still, while another person attempts to produce change while avoiding direct contact at all cost.

Over the course of three afternoons, the sitters included a timid and airless chamber, Boris Charmatz and tie, a dancer and a small child. Performing alone or together, Charmatz and Cima responded to the stone-like presence of the sitter by unleashing the force of their vitality into the close atmosphere of the small room. Sometimes they moved slowly and stealthily, at others they paced or loped around, banging into walls or hurling objects through the air to thud against them; sometimes they turned the lights up to a level of unbearable brightness or switched them off, plunging the room and its audience into suffocating darkness; sometimes they read texts out aloud, whispered stories, sang, hummed or uttered strange, guttural sounds. Throughout all this, the sitters seemed to maintain their composure in the performer's often-uncomfortable proximity. One man admitted to having been close to tears from the tension of the situation; a woman claimed to have found the situation deeply erotic; a six-year old, who had watched several performances before gamely taking to the chair, was visibly less inhibited in his responses to the unseen yet obviously keenly sensed attitudes of the performer. He smiled, dozed, wrinkled his nose like a rabbit and, finally, getting a bit bored began counting visibly but silently "to see when he [the performer] would finish." The space and the performance were, therefore, completely determined by the inert presence of the sitter; the usual sovereignty of the gaze that is part of all dance and body work was counterbalanced by the fact that everyone watching the performance could also feel the possible sensations that the sitter was experiencing. This was most evident in the instance of the child, where the audience became absorbed in the most minute of his facial expressions over the physical antics and exertions of the performer.

In the "pure space" of the performance, one was reminded that just as early conceptual art experiments actively challenged the viewer's relation to the art object and to him/herself in the gallery space, dance experiments from the same time tested the viewer's perceptions about his or her own physical and psychic bearing relative to what s/he saw and experienced. In this spirit, *danse suggérée* sets up a trichotomy in the space that equally challenges all participating parties — performer, sitter and audience.

127

From *fantômes:*

Be critical but don't fall into asceticism or didacticism. Continue to work on a physicality that is not deceiving and that renders its figures live and actual. Be reactive not as a mode of functioning but rather as a parade, a protection when things start to become stuffy. Be in debate with what has been done and what is being done, without necessarily seeking to think in terms of "coming out of" or "following" ,even worse, of "synthesis". Choose affinities in the past, while rethinking the forces and forms from the point of view of other ways of working. Situate and demarcate yourself: in confronting others you exist, in exposing yourself to another,in internal dialogue with other figures and works. This attitude is not carried by an obsession with rejection; these "others" are taken on as stimulating fictions.

Continuity and discontinuities:

Les Disparates, a captivating collaboration between Boris Charmatz and filmmaker César Vayssié, after a choreography by Charmatz and Dimitri Chamblas, takes dance out into the urban environment, mixing references high and low, from nouvelle vague to the film musicals of Jacque Demy. Demy's *Les Demoiselles de Rochefort* (1966), also set in the historic French port city, is a rare oddity in French cinema, with its air of ironic optimism. *Les Disparates* is similarly captivating, bubbling with Charmatz's vitality and mercurial wit, as he is tracked, promenading and gambolling through the city in fast-forward.

Les Disparates, as the title suggests, is a unity of parts that places at its centre Baudelaire's poetic social construction of the *flâneur*, the ultimate hero of modernity who seeks to give voice to its paradoxes and illusions, who participates in, while giving form to, the fragmented, fleeting experiences of the modern.

Vayssié's exploratory camera tracks the dancing figure of Charmatz through the geography of an urban environment (the port of Dieppe) in a kind of absentminded "reading", thereby turning it into a space of abstract signs. Subverting the proposed unities of time, place and action in theatrical representation, Vayssié's cinematic jumps and skips underscore Charmatz's dislocations to different places — a bridge, a factory, a swimming pool, a bar, a boardwalk — producing a reading of the city that is momentary and invariably fragmentary.

Like Baudelaire's *flâneur*, Charmatz's character adheres to the alternative vision that Charmatz himself proposes in *Entretenir*, a supple, ironic vision that is more optimistic than the intractable dogma of "power-knowledge". The wry and sardonic potential built reflexively into Baudelaire's figure enabled him not only to resist commodity form, but to penetrate its mode of justification, precisely through his unerring scrutiny. The march of modernity was thus held in check by the Nietzschean dance of the flaneur. But at this point the comparison begins to falter. The earthbound mannerisms of Baudelaire's

ungainly *flâneur* — the "retracing," the "rubbernecking" and the "taking a turtle for a walk," all acknowledgments of the city's physical obstacles and thus critical rebuffs to the late-modern politics of speed — are countered by Charmatz, for whom the environment and its man-made features provides an endless source of fascination and, thus, potential for physical expression. He skips, glides, leaps, skids, hovers: an exuberant, gravity-defying, postmodern creature of air.

Les Disparates contains, along with many allusions and play with space, time and humour, the unassailable force of the dancing body. The choreography of Dimitri Chamblas and Boris Charmatz, explores such notions as exhaustion, weary perseverance, energy and effort. With an evident technical mastery that mixes learning with real discoveries inspired by a particularly inventive choreography, César Vayssié has succeeded in creating an autonomous cinematographic work out of a live choreography. And this is the intention: Charmatz and Association Edna once again playing with the constraints defined by form by experiencing the limits from the inside. Because this dance film — where the dancer can be a small silhouette with nose, feet and hands reddened by the cold, or a Keatonesque character slipping and sliding around in the local café — is no longer really a "dance film", but rather a "danced film."

Louise Neri

Endnotes:

[1] Huizinga developed these thoughts into a book, published in 1938 as *Homo Ludens* (English translation: New York: Roy Publishers, 1950)

[2] Roger Caillois, *Man, Play and Games*,(Illinois: University of Illinois, 2001), 58

[3] ibid ,3

[4] "Entraînements" was developed in collaboration with the Siemens Cultural Program and specific social and cultural institutions in the city of Paris.

[5] *Entretenir/a propos d'une danse contemporaine* (Paris:Centre National de la danse/les presses de réel, 2003).

[6] Caillois, op.cit, 7

* Author's title is a nod to Chantal Pontbriand's essay, "Dance in the Expanded Field" in which she applied Gene Swenson's groundbreaking theory of "expanded cinema" to the field of dance and movement studies.

MELISSA McGILL

若斷而連續熔铅盡鈞自其一形質即自其一造

上而且宗通臺合如朱之被如水之派若瓴而實繁

化也故欲之者名名王独得其皴而皴之者公此

浮此始傳其神歟

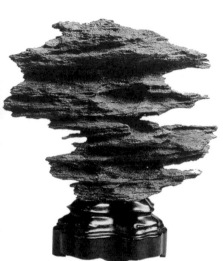

Hands Holding the Void

Nothing disappears completely... nor can what subsists be defined solely in terms of traces, memories or relics. In space, what came earlier continues to underpin what follows.
- Henri Lefebvre

Melissa McGill operates precisely through the rhetoric of the production of space. This assertion is implicit in the processes by which her sculptures are produced but is articulated most explicitly by the autonomous results of this process, that is to say, by the works themselves. Nothing disappears completely, and yet, the flawless porcelain forms, "personages" as they would once have been known, have the most fragile of relationships to the spaces that gave shape to them; spaces which they seem subsequently to have outgrown to the point of near complete contradiction. But what came first continues to underpin what follows. That is to say that facing the finished work, an absent original suggests itself, remains in the corner of the eye; an eye necessarily cast askance.

It is, after all, just possible to make out the most elementary details of Bernini's Baroque sculpture *The Ecstasy of St Teresa* in McGill's wall drawing *Shadow of Ecstasy*, but to seek to resolve the original work through the refracting lens of its descendant is to fall for too seductive a resolution. The mannerist flourishes, which stigmatise the original, refuse to disappear completely, suspending a memory of billowing marble somewhere between the present work and its satisfactory apprehension. Indeed, the material that McGill uses in her work, a slick, reflective black rubber, offers far more than a representation of the shadows cast in and by Bernini's sculpted marble surface. The patches of rubber account collectively for the play of light over the surface of Bernini's sculpture, captured by camera, and projected, multiplied and reversed over the gallery wall. Once installed, these painstakingly cast "shadows" offer their own responses to light, both individually and collectively, as the viewer moves within the space of the work. In places, the arrangements of shiny black forms double, as they in turn catch the light reflected across the corners around which they spread: found forms multiply, gesture to one another and generate their own intricacies. This complex play of reflections is as evident in photographs of the finished work as the shadows in the photographic projections on which it was based.

A very different set of photographs help to situate McGill's untitled porcelain personages: smiling, colourful figurines, brilliantly lit and uncannily close: coy pixies, blushing urchins, diminutive oriental figures, a metallic shirted accordion player with a miniscule head. Without the aesthetic gloss of professional photography, the ensemble could perhaps suggest the disinterested acquisition of unfashionable collectables. But these merry figurines, found and redeemed, are connected with the ghostly porcelain forms that they introduce in the strangest possible way.

The result of the process by which these ornamental crimes were mass-produced means that within each tiny figure is a previously unlooked for, unheeded space. It is these spaces that McGill has found and subsequently reconstituted. So the tiny, disproportionate accordion player contains the form of a porcelain sculpture many times larger than itself. But the mute form of the personage speaks only of a relationship to a body of sorts, never once admitting its humble origins. The fantasy of art, Lefebvre tells us, "is to lead out of what is present, what is close, out of representations of space, into what is further off," into what he calls "representational spaces."[1] As the gap opens up between representations of space and representational spaces, flowing robes cease to articulate a simple opposition between positive and negative, matter and void, a hand and the gaps between its fingers.

In McGill's sculpture the concept of space is always contingent. Progress towards the autonomous object through the process of its facture depends upon breaking the umbilical cord that ties it to its origin without ever completely disavowing existence of the place of origin or its derivative status. So the photograph of the accordion player can be present for the sculpture to which it relates without either work depending upon the other. But in the course of its production and subsequent reception, the finished work turns against and opposes its progenitor, not only through its form but its scale, colour and surface. These descriptive differences are key to the principle antinomies of abstraction and legibility: through what can accurately be called a *process* of abstraction, an easily recognisable figure offers something disarmingly unlike itself. In these terms, abstraction, rather than operating in opposition to figuration, is confirmed as that which figuration produces under pressure. The accordion player is readily legible, while its sculpted counterpart resists, rather than refuses, the idea of the body in a series of counterpoints.

The contradiction in scale is the most immediately obvious; after all, the porcelain personage is many times larger than the original space from which it was drawn. Elsewhere in McGill's work, both rubber and porcelain forms were cast to the same scale as the original objects and, like their forebears, were displayed and photographed in groups. In this way, the found, cast interiors of absent others retained a collective identity, suggested by their scale, but confirmed by a gentle morphological gradient from near-complete figure to unidentifiable abstract form. The contradiction in scale generated by the large personages is reinforced by the transformation in colour and tone from polychrome exuberance to neutral monochrome. However, given that it is the internal logic of the original figurine that is relevant here, what occurs is less of a rejection of colour than a reversal of surfaces. The surface usually left unfinished, facing the void inside the object, is reversed and accorded the fine polish normally reserved for exteriors. This observation hinges upon underlying assumptions about the hierarchy of surface quality, where the investment in the degree of finish guarantees the status of the work as final, complete and aesthetically autonomous.

A further feature of the porcelain personage is that it too was cast and finished and it too contains its own internal space, suggesting far more than just anamorphic similarity: a narrative of infinite regression, Russian dolls, an endless series of found spaces. This is familiar territory; McGill's versions of originals generate their own continuities, a void here in place of the reflections, created within and across *Shadow of Ecstasy*. The care and attention that McGill offers these foundlings, evident in photographs of the artist at work at the Kohler porcelain factory, stands in stark contrast to both the production-line paint job of the accordion player and the limits that time and motion studies impose on the commercial products to whom the personages are cousins, many times removed.

Despite the series of oppositional aspects of the relationship between form and space there remains the material continuity: the porcelain itself, transformed, made unlike itself, uncomfortable with it's own skin. Porcelain could be said to have its own significance, from fragile (and thus precious) commercial collectibles to industrial-strength, mass-produced toilets and bath tubs. *Fountain*, Marcel Duchamp's most famous porcelain "sculpture" offers an inviting point of reference for McGill's work, which returns to the source material of the original readymade to reroute the found object in the direction of found space. *Fountain*, however, like the accordion player, was only the beginning of a process of abstractions from an original object to a finished sculptural form. The result of the simplest act of appropriation, *Fountain* was subsequently complicated by the intervention of Alfred Steiglitz. In the light and shadow of an ordinary urinal, as it lay on its porcelain back, Steiglitz photographed the miraculous outline of the Madonna, her intimate plumbing crudely denoted by the shadow cast in a pipe hole.

There is no direct analogy or historical precedent for McGill's work in this anecdote. Rather what it offers is evidence of a pre-existing logic of appropriation and contingency that binds the production of sculpture to the production of space. And that implicit in this process is the distance generated by the camera lens. The nature of the relationship between points of origin and the works themselves is that of an oppositional contingency sustained by resolute independence. The spaces found and produced are related in such a way that nothing disappears as completely as fact of the link between them. As Lefebvre suggests, "relative spaces, for their part, secrete the absolute."[2]

Simon Baker

Endnotes:

[1] Henri Lefebvre, *The Production of Space*, trans. Donald Nicholson-Smith, (Blackwell: Oxford, 1991), 231-2

[2] Ibid, 233

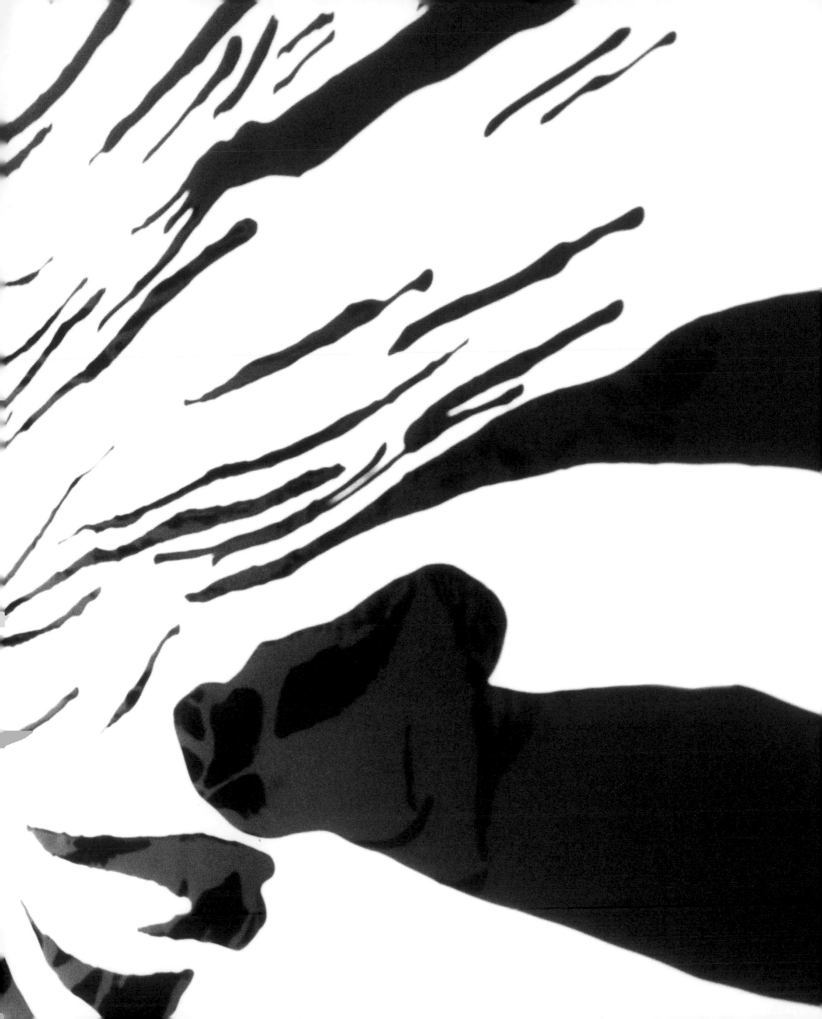

KYOICHI TSUZUKI

Imekura/Image-club

You are not even looking at the room.
Does anyone care about the interior when the girl in front you is about to take her bra off and pull her underwear down?

But looking around the room after you have safely ejaculated, you might realise how strange the space is: A tiny space like a prison cell or interrogation room, subdivided by plywood so thin that you wouldn't want to call it a wall. For some reason, there are straps hanging from the ceiling, a vaulting horse and a mattress; or there is a doctor's consultation stand in a bland space not even covered with wallpaper.

Imekura or "image-club" is really a very strange service. It is a temporary space that embodies a customer's wildest fantasy, such as "being molested in a train", "sexual harassment in an office", or a "secret visit to a girl's apartment." Inside the room is the customer, aroused by his fantasy, and an imekura girl who faithfully plays her role as an object of desire. She wears a costume that corresponds to the scenario (a school or office uniform, a nurse's white dress, and so on) and plays a set role in the story of the customer's desire (Some meticulous customers even bring their own original scripts).

Eventually comes the liberation of desire named ejaculation. However, ejaculation in the context of imekura only indicates a false act guided by the rule of "no insertion", such as masturbation and sumata (where a masseuse puts the customer's penis between her thighs and massages it with lotion instead of having actual sex). In other words, there is no requirement for the illusory and temporary love relationship that a conventional, hard-core prostitution industry demands.

For a customer, an imekura girl is merely a character who appears in his internal pornography landscape. In return for that, he happily pays the price of 20,000 yen – by no means cheap – per "play". For that price, anyone anywhere in Japan would be able to get an average, hard-core prostitution service, but there are some men who rather choose to immerse themselves in the world of false fantasy. They make phone calls on weekday mornings, make reservations with their favorite girls, and visit imekura. Diverting from the conventional flow of sex (foreplay, insertion, and ejaculation) the deliberate act of making a means to an end, imekura indeed symbolizes the dynamic of the typically Japanese imagination. The same can be said about the powerful existence of "love hotels", decorated with gimmicks not directly related to pleasure; or the motorbikes of Japanese Hell's Angels or long-distance freight trucks, both excessively decorated.

No one would consider imekura as art. But what would happen if it were reproduced in a stylish contemporary art museum rather than in a mundane, multi-purpose building? Wouldn't it appear to be a wonderfully difficult piece of conceptual art? By nature, imekura is an extreme opposite to simulation art. In the former, a nameless artist, collector and visitor together run a risk of violating the law, getting arrested, and being forced to close the business. In fact, it is a truly revolutionary project taking place in a huge museum called "the street".

Kyoichi Tsuzuki

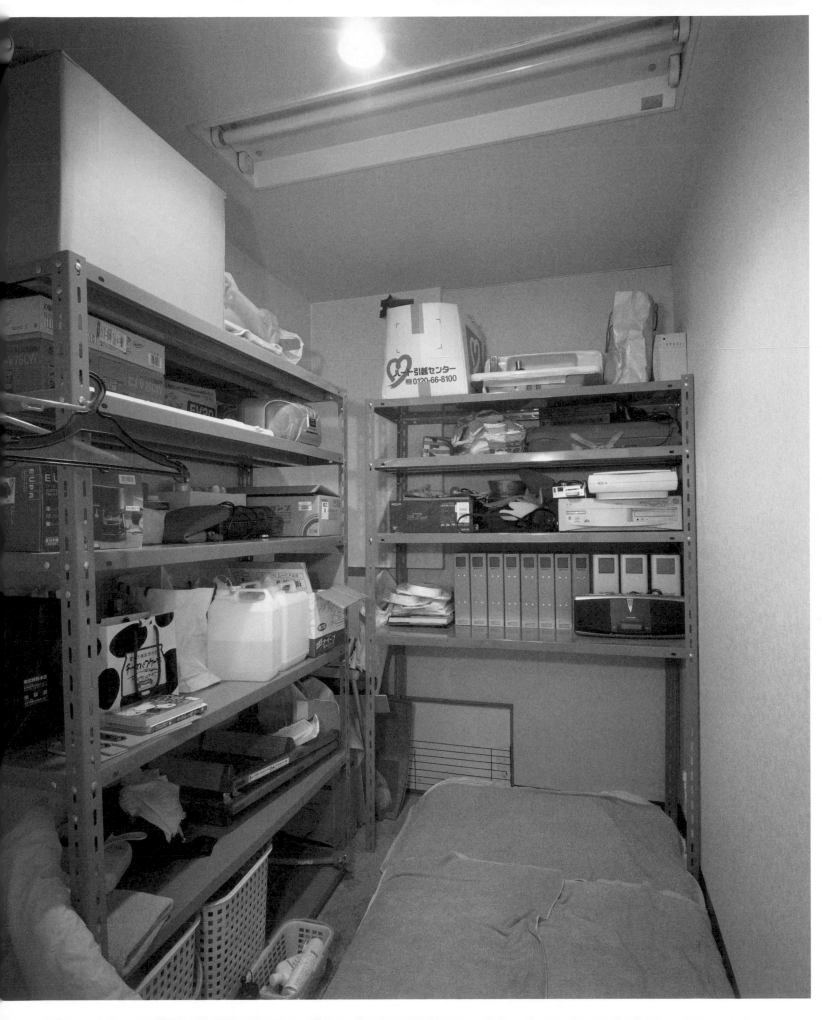

You explain your story (your obsession), tell her to say/act so and so if you say so and so, and the performance starts. All the services are done in these small rooms. In a way it is a theatrical play behind a closed door, just by you and her as actor/actress/viewer.
- Kyoichi Tsuzuki

By stepping into this darkened room, two screens and four beanbags on the floor, you might be in Tsuzuki's shoes. In the gallery as viewing room, you are sharing his subject, a remarkable series of projected photos that document a new type of sex space, the *imekura*.

This installation represents a particularly artful stage in Tsuzuki's ongoing series of photographic studies. He is an expert at observing the absurdity of the everyday. His books (including *Roadside Japan* and *Tokyo Style*) are essential references for any study of Japanese lifestyle. In *Tokyo Style*, he chose not to represent the chic and the glamorous, but the cluttered, most un-*feng shui* of homes, with jeans hanging from washing lines across the bed, or whole rooms lined with music systems or fluffy toys. These crammed rooms may seem bizarre to the foreign viewer, while in reality, the premium on space means they are commonplace in Japan; *imekura* may not be so familiar to average Japanese, but they will not be surprised that they exist. They reflect the need for a bizarre dimension within the everyday. *Roadside Japan* reveals the fine line between light-hearted entertainment and the everyday accommodation of sex as a service industry. Page after page of weirdly conceived museums and entertainment spaces, gradually cross over into the sex museum and ultimately to the tackiest casino or public attraction.

Tsuzuki's studies inevitably lead to the curious interior world of the love hotel, with each room kitted out to appeal to the fantasies of the guests whether these are overtly romantic or hardcore S&M. It seems that in Japan, there is an ever-present demand for access to fantasy as an escape from crowded everyday reality.

In the gallery, as if to add a hint of the *imekura* performance, the projected images are accompanied by faint sounds of women during lovemaking. The pictures are presented as slides, and not prints. Sharp and made of light, a slide has a first hand quality that withstands the mediated effect of the printing process. We see more or less what the photographer saw as he peeped from his corner in the place of the punter, though without the girl.

It is the absence of the girl that might make you mistake these spaces for ordinary rooms. As you gaze through the dark from the comfort of your beanbag, you cannot help wondering why they are so odd. And the reasons are not simple. Partly it is because they are empty, but also because they are both ordinary and staged.

In reality each room is a conversion of a tiny space into a contained theatre set. There is no auditorium because the audience of one is in there with the performer. He has chosen the girl and her costume, the outline of the performance and the space that together, they'll be in.

Tsuzuki's pictures gather together dozens of these rooms, collecting them into a lexicon. Many have rather squalid little futons, sometimes in the corner of the room and sometimes as though improvised. Many depict bedrooms or living rooms, but as fragments or corners. Others pretend to be public spaces, in the workplace or on the street. There are even a couple of rooms pretending to be inside train carriages.

Most pictures are taken at an angle because like that, he can tell us more about the disposition of the various components that make up the set, as well as helping us imagine being in the room. (We would have to stand back too, if we wanted the full effect.)

As any visitor to Japan will know, entertainment often takes place in intimate spaces. Tiny bars like the thousands hidden away in Roppongi or Shinjuku will often only have one group of customers, or even one.

There, service has a performance tradition quite unlike the West. Often there will be an unbalanced disconnection between the in-house side of the bar and the one for the customer. Whether serving sushi or a whisky, restaurants and bars are frequently designed to emphasise a disconcerting way of performing one to one. Sometimes the customer sits in a hole in the floor, or the people behind the bar might be sitting as they serve. The variations on these themes of relationships in space are endless.

These common places often invent their own subtle conditions for playing games of control, adding to the pleasure of the one who's paying. Control is often part of the scene, as witnessed in the stories in many *manga* mags. Rape is a favourite in many of these magazines. And the more violent the scenario the better.

Compared with this violent imagination that might entertain you as you flick the newsprint pages on your way to and from work, I imagine that the performances in the *imekura* are a more subtle after-hours activity. In fact isn't it this subtlety that sets up their erotic discourse? These pictures translate that same subtlety by the absence of the performers. It is their absence of sex that makes them so erotic.

So here we are, illicitly, peering into a world that has seen many scenes. You don't consider what may have happened there last, and whether you can surpass it. Like hotel rooms, these have no traces of the previous occupants. The bed is perfectly remade each time. They have no history and no future. But unlike pictures of the rooms in love hotels, when looking at these, you have the same vantage point as the punter, part voyeur and part director. They're purely for the pleasure of the viewer.

Nigel Coates

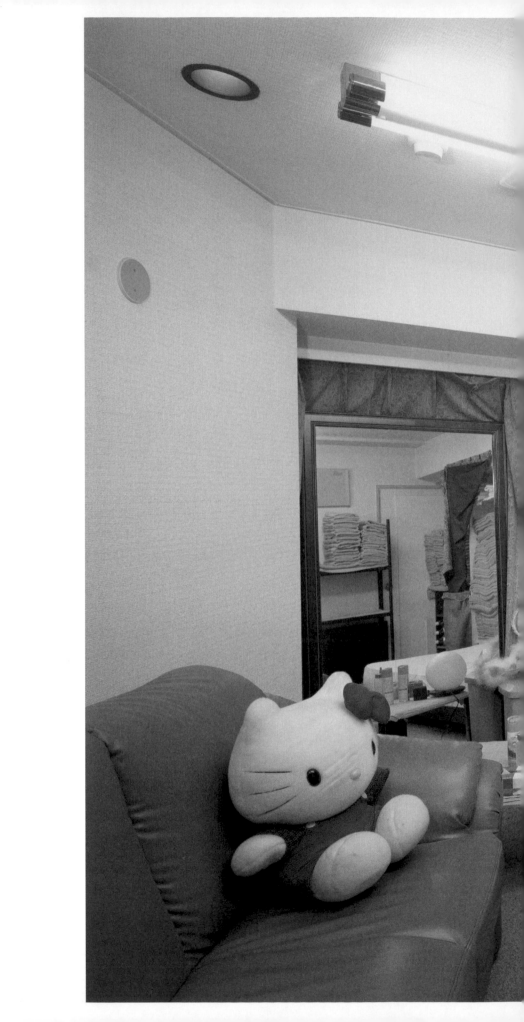

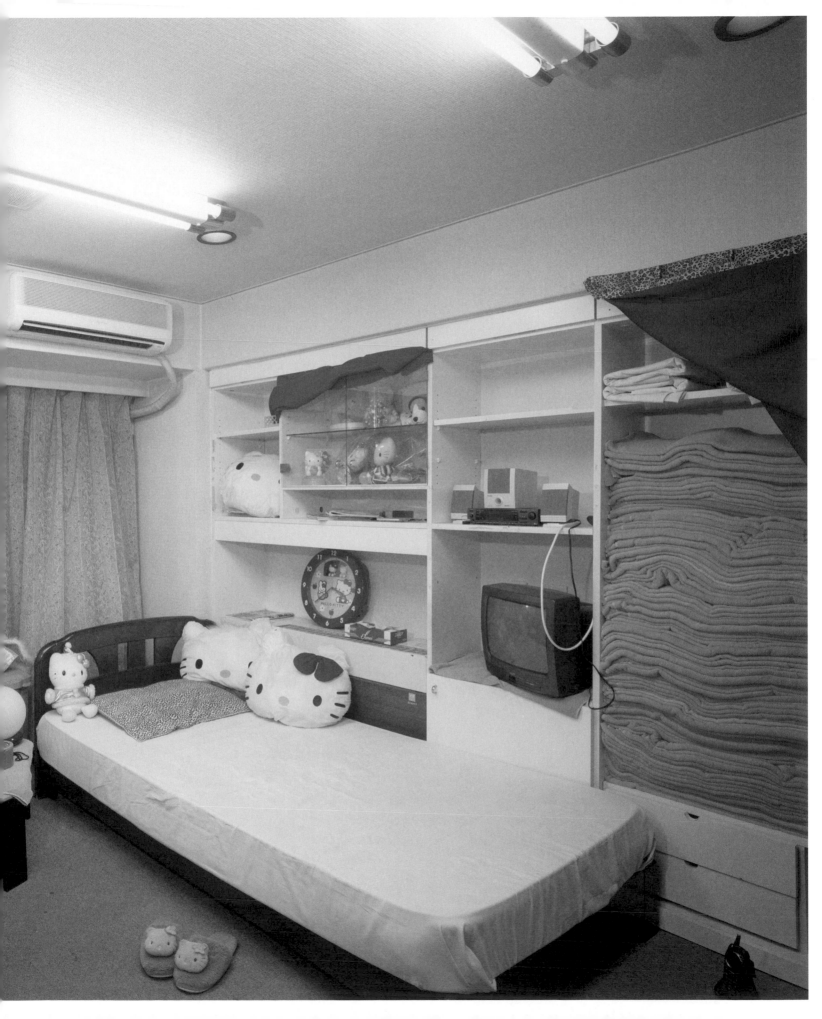

Exhibition chronology and list of works

Artists' and writers' biographical notes

Acknowledgments

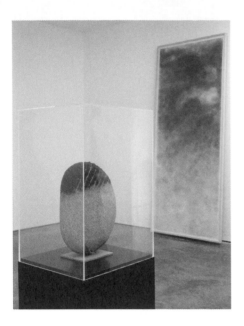

David Hammons
26 September - 2 November 2002

Rock Head
2000
Hair, rock and metal stand
38.1 x 25.4 x 22.8 cm

Travelling
2002
Harlem earth on paper, suitcase
295 x 124.5 x 21.5 cm

Site-specific action
2003
Harlem earth
Dimensions variable

Born in 1943, David Hammons studied in Los Angeles at the Chouinard and Otis Institute of Fine Art and at Parsons School of Design in New York. He lives and works primarily in New York City. Eschewing regular gallery representation, Hammons has developed his own private economy, exhibiting occasionally in Europe, Asia and the U.S. in specific and often unusual public and private contexts. Among recent major projects were *Global Fax Project* at the Palacio Cristal in Madrid (2000), where he collaborated with composer Butch Morris; *Concerto in Black and Blue* at Ace Gallery in New York (2002); and *Holy Bible: The Old Testament*, a book produced by Hand/Eye projects in London (2002). The opening show at Inside the White Cube was his first solo exhibition in London.

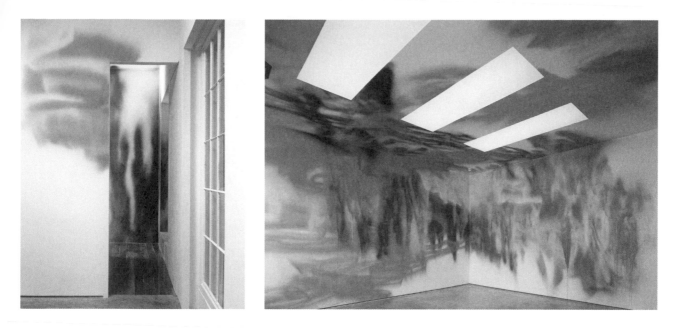

Katharina Grosse
5 November - 30 November 2002

Untitled
2002
Site-specific painting
Spray acrylic
Dimensions variable

Born in 1961, Katharina Grosse lives and works in Düsseldorf, Germany. In the early years of her career, she experimented with various unorthodox forms and techniques relating to colour-field painting, as well as making chalk wall drawings in disused buildings. Converging circumstances prompted her to make her first spray-painting in a group exhibition at the Kunsthalle Bern in 1998, going beyond the physical limitations of the brush in order to reveal new visual potentials in the given site. Since that time, Grosse's spectacular site-specific paintings, which range from diaphanous monochromes to explosions of layered psychedelic intensity, are appearing all over the world in private and public contexts, both as temporary and, more recently, permanent commissions. In 2002 she had solo exhibitions at the Ikon Gallery, Birmingham, and the Lenbachhaus in Munich. She recently completed her largest permanent commissioned work to date, an eighty-metre wall painting at Toronto's new international airport.

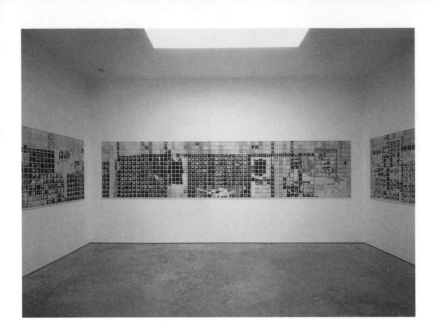

Daido Moriyama
3 December 2002 - 4 January 2003

Polaroid Polaroid
1997
Polaroid photographs mounted on paper
panels
122 x 1942 cm

Born in 1938, Daido Moriyama is widely
recognized as one of Japan's pioneering
post-war photographers whose work
prefigures the strategies of much current
cutting-edge photography.
The diversity of moods, angles, and
startling configurations that populate
his photographic images and remarkable
books attests to more than thirty-five
years at the forefront of the photographic
medium. A large survey exhibition of his
work "Stray Dog" was organised by SF
MoMA, San Francisco in 1999 and travelled
to The Metropolitan Museum and The Japan
Society, New York.
The first European survey of his work
will open at the Fondation Cartier pour
l'art contemporain in Paris in 2003.

Daniel Roth
7 January – 1 February 2003

701XXKA
2002
Mixed media installation
Duration of installation cycle:
10 1/2 minutes
C-print, graphite wall drawings,
framed invoice, slide show,
graphite panel drawing, twig sculpture
Dimensions variable

Born in 1969, Daniel Roth creates
gallery installations comprising
photography, projections, sculpture and
graphite wall drawings as fragments of a
narrative that can relate across space
and time. Melancholic and strange,
Roth's meticulously devised scenarios
draw the viewer into a tentative process
of investigation where no object can be
taken at face value. In the last two
years, Roth has made solo exhibitions at
Maccarone Inc, New York and Meyer Riegger
in Karlsruhe, as well as Grazer
Kunstverein, Kunstverein Aachen and
Museum der Bildenden Künste, Leipzig.
He lives and works in Karlsruhe, Germany.

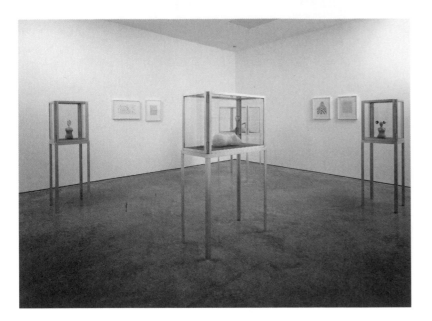

Louise Bourgeois
4 February – 1 March 2003

Reparation
1990
Cotton thread on paper (double-sided)
25.4 x 27 cm (p.87)

Untitled
2002
Red ink and pencil on paper
21.6 x 43.2 cm

Untitled
1997
Ink on manuscript paper
27.9 x 20.6 cm

Dissymetrie is Tolerated if not Encouraged
2002
Ink and correction fluid on paper
30.2 x 22.9 cm

Untitled
1997
Ink on manuscript paper
27.9 x 21 cm (p.87)

Untitled
2002
Red ink on paper
22.9 x 30.2 cm

Untitled
1997
Ink on manuscript paper
27.9 x 20.6 cm (p.82)

Untitled
2002
Fabric, steel and wood
35.6 x 38.1 x 15.2 cm

Untitled
2002
Fabric and steel
30.5 x 11.4 x 10.2 cm

Femme Couteau
2002
Fabric, steel and wood
22.9 x 69.9 x 15.2 cm
(pp.84–85)

Untitled
2002
Fabric and steel
27.3 x 12.7 x 10.2 cm
(pp.83, 88–89)

Born in Paris in 1911, Louise Bourgeois
studied mathematics, then art in Paris,
and was apprenticed to Fernand Léger.
She emigrated to New York in 1938.
She first worked as a painter and engraver,
and in the 1940s she began to develop the
varied sculptural language for which she
would be so highly acclaimed. She
continues to exhibit her work extensively
in museums, galleries and large survey
exhibitions all over the world, including
a gigantic site-specific commission in
the Turbine hall of the Tate Modern,
London (2000) and a major presentation of
drawings in Documenta XI, Kassel.
She lives and works in New York City.

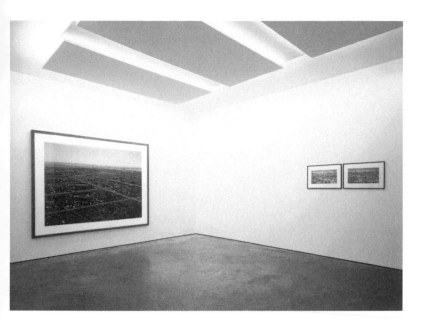

Andreas Gursky
4 March – 29 March 2003

Greeley
2003
C-print
210 x 260 cm

99 Cent II
2001
C-print
Diptych, each panel 45 x 65 cm

Born in 1955, Andreas Girsky lives and works in Düsseldorf, Germany. A retrospective survey of his work, opening at the Museum of Modern Art, New York in 2001, travelled to Museo Nacional Centro de Arte Reina Sofia, Madrid; Centre Pompidou, Paris; MCA Chicago and SF MoMA, during 2002-3.

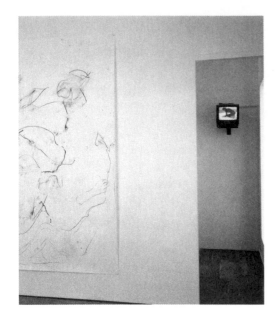 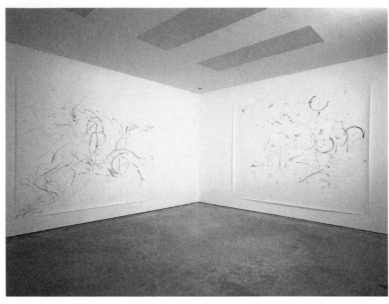

Trisha Brown
It's a draw
1 - 19 April 2003

Untitled
2003
Charcoal and oil pastel on paper
270 x 320 cm (p.113)

Untitled
2003
Charcoal and oil pastel on paper
270 x 320 cm (p.115)

Untitled
2003 (p.117)
Charcoal and oil pastel on paper
270 x 320 cm (p.117)

Untitled
2003
Charcoal and oil pastel on paper
270 x 320 cm (p.119)

Born in 1936, Trisha Brown is a leading
figure in postmodern dance. She was an
original member of the vanguard Judson
Dance Theater in New York in the 1960s,
and has spent her life working at the
crossroads of dance, performance and
visual art, collaborating with sculptors,
painters and filmmakers. She founded her
own company in 1970, with whom she
conceived pieces for alternative sites,
such as the roofs and facades of
buildings. In the 1980s she began
exploring more complex ideas of cyclic
dramaturgical structure, most recently
extending as far as opera with *L'Orfeo*
(1998) and *Die Winterreise* (2002). An
exhibition "Trisha Brown: Dance and
Language in Dialogue 1961-2001" opened
at the Addison Art Gallery, Massachusetts
in 2002, travelling to the New Museum of
Contemporary Art, New York in 2003.

Boris Charmatz, Dimitri Chamblas,
Julia Cima, César Vayssié
22 April - 3 May 2003

Danse suggerée (Suggested dance)
22 - 24 April 2003
Boris Charmatz and Julia Cima

Live improvisations by Boris Charmatz and
Julia Cima lasting approximately half an
hour each, over three days.
Each performance required the
participation of a member of the public.

Les Disparates
Film by César Vayssié,
choreography by Boris Charmatz
and Dimitri Chamblas
35mm film transferred to DVD
Duration: 22 minutes

Born in 1973, Boris Charmatz founded
Association Edna with Dimitri Chamblas
in 1992. Together they choreographed and
danced *A bras le corps* (1993) and *Les
Disparates* (1994). Charmatz went on to
choreograph *Aatt enen tionon* (1996),
herses (une lente introduction) (1997)
Con forts fleuve (1999). During 2000-
2001, he worked on a series of projects
(*Education*, *Facultés* and *Statuts*) aimed
at a multiple approach to dance and the
body. He continues to develop and
participate in diverse choreographies and
improvisational activities. Since 2002,
for a period of three years, as a
research and development fellow at the
Centre National de la Danse in Paris,
he is developing BOCAL, a provisional and
nomadic school for dance.

Born in 1974, Dimitri Chamblas is a
dancer and choreographer who works with
choreographers including Regine Chopinot,
Mathilde Monnier. In addition to the
choreographies that he developed together
with Charmatz, Chamblas collaborates on
and directs audiovisual projects, as well
as projects combining dance and video.

Born in 1975, Julia Cima works with
choreographers including Myriam Gourfink
and Alain Michard, as well as developing

her own projects, such as *Combinaison(s)*,
a work for dance and voice; workshops for
non-dancers, and regular improvisation
work. Since 1996 she has participated in
and interpreted Charmatz's choreographic
work.

Born in 1967, César Vayssié has made
many short, medium and feature-length
experimental films and videos. He also
works in advertising film production.
His most recent film projects include
Elvis de Medicis, *The Circle X* and
Aujourd'hui Madame.

Born in 1992, Association Edna designs
situations for multifaceted choreographic
experimentation. This research takes on
varied forms - thematic sessions on the
arts, film production, exhibitions, and
the creation of settings for reflection
and criticism. Most recently,
Entrainements (2003), a series of
choreographical events and interventions
throughout Paris, was organised in
collaboration with the Siemens Cultural
Program.

Melissa McGill
6 May - 1 June 2003

Untitled
2002 (p.137)
Porcelain
165.1 x 61 x 61 cm

Untitled
2002 (p.138)
Porcelain
114.3 x 83.9 x 66 cm

Created in Arts/Industry, a long-term
residency program of the John Michael
Kohler Arts Center, Wisconsin.
Arts/Industry takes place at and is
funded by Kohler Co.

Shadow of Ecstasy
2003 (pp.140-141)
Silicone rubber
Dimensions variable

Melissa McGill and E. Michael Quinn
Untitled
2000
Folio of six C-prints
Two: 35.56 x 27.94 cm
Four: 27.94 x 35.56 cm

Born in 1969, Melissa McGill lives and
works in Brooklyn, New York. A residency
at the Kohler industrial porcelain
factory in Wisconsin enabled her to
explore her work on a monumental scale.
This resulted in the sculptures that she
exhibited at Inside the White Cube,
marking her first major exhibition in
Europe.

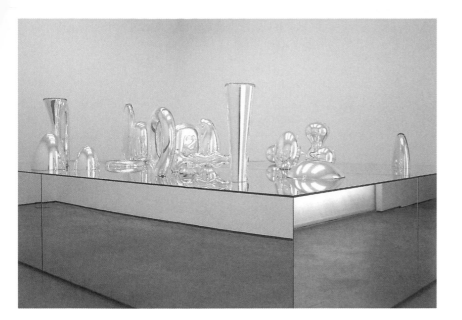

Josiah McElheny
4 - 28 June 2003

*Model for Total Reflective Abstraction
(after Buckminster Fuller and
Isamu Noguchi)* 2003
Mirrored glass, wood and mirror
124.5 x 365.7 x 223.5 cm

Born in 1966, Josiah McElheny studied
at the Rhode Island School of Design.
He trained extensively with master
glassblowers in Sweden, Italy and the
U.S. In 2001, he staged *The Metal Party*,
an installation/performance project
produced by the New York Public Art Fund;
and his work was the subject of a major
survey exhibition at the Centro Galego
de Arte Contemporanea in Santiago di
Compostela, Spain in 2002. It was
accompanied by an eponymous publication,
extensively illustrated. He is currently
preparing a project for the Museum of
Modern Art in New York.

Christian Marclay
1 July – 2 August 2003

Born in 1955 in California, Christian Marclay grew up in Switzerland. He returned to the U.S. in 1977 and currently lives in New York City. He has been performing and recording music throughout Europe, Japan and the U.S. since 1979. His sculptures, installations and projects in musical culture have been exhibited in museums and galleries internationally, including the Hirshhorn Museum and Sculpture Garden, the Kunsthaus Zurich and the Whitney Museum of American Art. In 2003 Marclay had concurrent museum exhibitions in the U.S., a project at the Philadelphia Museum of Art entitled "The Bell and the Glass", and a touring survey of his work, which opened at the UCLA Hammer Museum in Los Angeles.

Fron left to right:

Hair, 1992 (p.26)
Collage with record, 31.1 x 31.5 cm

Traverse City, 2000 (p.26)
C-print, 26.4 x 35.6 cm

Golden Voice, 1995 (p.26)
Gold spray paint on black record cover
31.5 x 31.5 cm

Berlin, 1996 (p.26)
C-print, 35.6 x 26.4 cm

Flute, 1994 (p.26)
Collage, 47.3 x 61.6 cm

Marseille, 1995 (p.26)
C-print, 26.4 x 35.6 cm

Boston, 2000 (p.27)
C-print, 35.6 x 26.4 cm

Untitled, 1984 (p.27)
Collage with newsprint, 35.6 x 50.8 cm

Echo, 1993 (p.27)
Monoprint, acrylic paint on paper
41.9 x 59.3 cm

New York, 2002 (p.27)
C-print, 35.6 x 26.4 cm

New York, 1999 (p.27)
C-print, 35.6 x 26.4 cm

Untitled, 2001 (p.27)
Photogram made with cassette tape
30.5 x 30.5 cm

San Antonio, 1999 (p.28)
C-print, 26.4 x 35.6 cm

Charlives, 1992 (p.28)
Collage with newsprint, 49.5 x 30.2 cm

Listen to the Grooves on Your Skin
1995 (p.28)
Paint and pencil on record cover
31.3 x 31.5 cm

New Delhi, 1994 (p.28)
C-print, 26.4 x 35.6 cm

Chicago, 1998 (p.28)
C-print, 26.4 x 35.6 cm

Golden Voice Study, 1995 (p.29)
Collage diptych, Each: 48.3 x 61 cm

New York, 2000 (p.29)
C-print, 35.6 x 26.4 cm

Study for Galatea and Pygmalion, 1989
Pencil on painted record cover with
grommet, 31.3 x 31.5 cm (p.30)

Mouth, 1992 (p.30)
Collage and thread, 24.8 x 31.4 cm

From Hand to Ear, 1991 (p.30)
Collage, 20.5 x 14 cm

Geneva, 1995 (p.30)
C-print, 35.6 x 26.4 cm

Double Tuba, 1992 (p.30)
Photocopies collaged on board
31.5 x 31.5 cm

Untitled, 1993 (p.30)
Unique photocopy, double exposure
59.4 x 41.9 cm

New York, 1998 (p.31)
C-print, 35.6 x 26.4 cm

Palermo, 2002 (p.31)
C-print, 35.6 x 26.4 cm

Montreal, 2000 (p.31)
C-print, 26.4 x 35.6 cm

Bent Guitar, 1999 (p.31)
Collage, 35.6 x 43.2 cm

Kyoichi Tsuzuki
5 - 30 August 2003

New York, 1996 (p.31)
C-print, 35.6 x 26.4 cm

London, 2000 (p.32)
C-print, 35.6 x 26.4 cm

Digestive System, 1992 (p.32)
Watercolour on photocopied collage
34.3 x 21.6 cm

Taped Tape, 1994 (p.32)
Collage, magnetic tape and adhesive
tape, 59.3 x 45.7 cm

Paris, 2000 (p.32)
C-print, 26.4 x 35.6 cm

Whistle, 1989 (p.32)
Collage with staples, 28 x 21.5 cm

Bavaria, 1996 (p.32)
C-print, 35.6 x 26.4 cm

Vienna, 1998 (p.33)
C-print, 35.6 x 26.4 cm

Time Line, 1999 (p.pp.20-21, p.33)
Pencil and pen on book pages
29.3 x 41.9 cm

Frankfurt, 1992 (p.33)
C-print, 35.6 x 26.4 cm (paper size)

Imekura/Image-Club
2002-2003
Two slide projections and sound
Dimensions variable

Born in 1956, Kyoichi Tsuzuki lives
in Tokyo. After working as an editor
for *Popeye* and *Brutus* magazines, he
embarked on an independent career,
writing and editing books on art and
design, including *ArT RANDOM*, a 102-
volume set of art monographs. Among
his many publications on contemporary
social anthropology, are the famous
Tokyo Style (1993) and *Roadside Japan*
(2001). In 2003 he began working on
an extensive documentation of weird
and wonderful sites in the United
States. In 2003, his work was the
subject of a survey exhibition
initiated by the CNEAI and shown at
various venues in Paris, including
the Centre National de la Photographie
in Paris and Galerie du Jour. One
part of this survey, "Happy Victims",
was shown at the Photographers Gallery,
London in 2003.

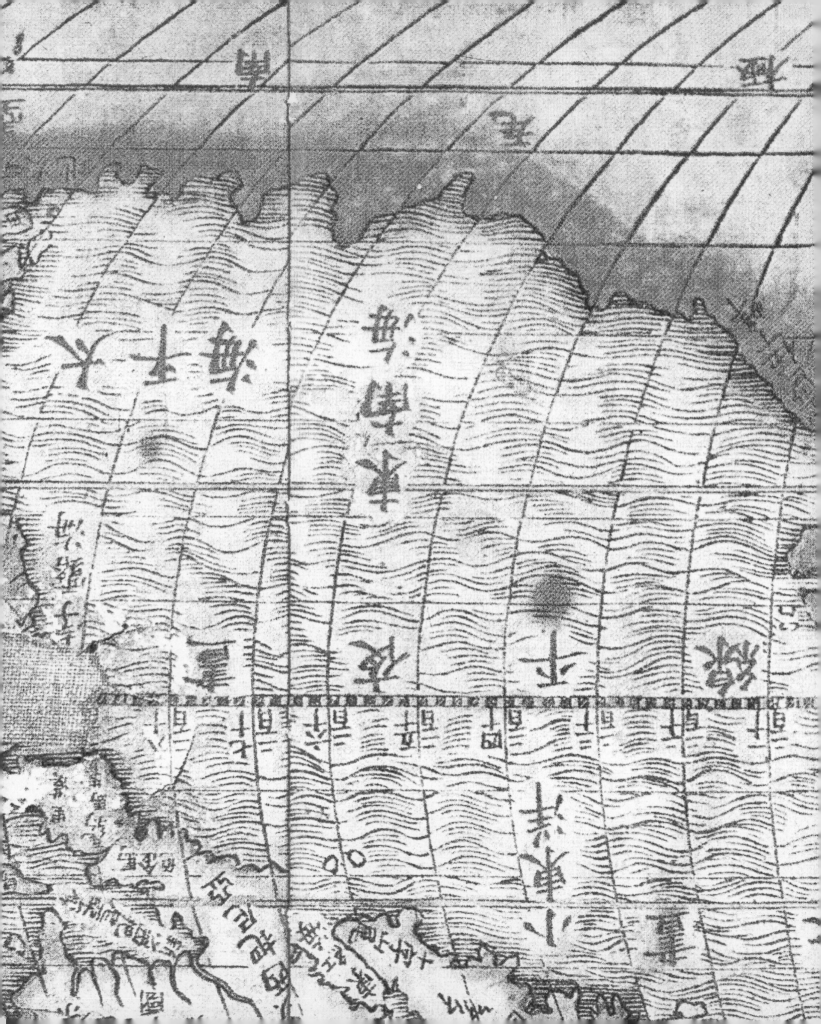

Authors' Biographies

SIMON BAKER is Gould Research Fellow at the Department of Art and Archaeology, Princeton University. He has written on Surrealism, its heritage and legacies; recently contributed an essay to a monograph on Julião Sarmento forthcoming from Poligrafa; and is currently working on an exhibition about the original French journal *Documents*, a project of the Hayward Gallery, London.

NORMAN BRYSON is Professor of Art History at the University of California, San Diego, and a Visiting Researcher at the Jan van Eyck Academy, Maastricht, the Netherlands. At the time of writing the essay for this book, he was Professor of Art and Theory at Slade College, London. He recently coedited *Gender and Power in the Japanese Visual Field* with Joshua S. Mostow and Maribeth Graybill (University of Hawaii Press, 2003). His publications include *The Art of Viewing* (Routledge, 2002) with Mieke Bal; *Looking at the Overlooked: Four Essays on Still Life Painting* (Harvard University Press, 1991); *Vision and Painting: The Logic of the Gaze* (Yale University, 1993).

NIGEL COATES is an architect, designer and Professor of Architectural Design at the Royal College of Art. His book *Guide to Ecstacity* (2003) is simultaneously a sourcebook, an architectural survey, novel and autobiography. He contributes a regular column to *The Independent on Sunday*.

LOUISE NERI is a curator, editor and writer who lives in Paris and works internationally. After organising the event series, "Public Life" at the Theater am Turm in Frankfurt in 2003, she has been made Artistic Director for the upcoming 2004 season in which visual and performing artists, scholars and producers will be brought together with the public in open and closed workshop situations, as well as performances, events and discussions to explore the evolving roles of art in the production of community and sense of place. (www.DasTAT.de) She has co-curated several large-scale exhibitions, including the Bienal de São Paulo (1998) and the Whitney Biennial of American Art (1997); and edited publications including the periodical *Parkett* (1990-2000) and books such as *Looking Up: Rachel Whiteread's Water Tower* (Scalo/New York Public Art Fund, 1999) and *Silence Please! Stories after the works of Juan Munoz* (Scalo/Irish Museum of Modern Art, 1996).

VIRGINIA NIMARKOH is an artist based in London. She is a director of Hand/Eye Projects, which produces artists' books and related projects. Her most recently published writing is, "Image of Pain: Physicality in the Art of Donald Rodney", in the monograph *Donald Rodney: Doublethink* (Autograph ABP, 2003)

MAI-THU PERRET is an artist and a writer who currently lives in New York. Together with Lionel Bovier she has edited *Timewave Zero: A Psychedelic Reader* (Revolver Verlag and JRP Editions, 2001).

ADRIAN SEARLE is chief art critic of The Guardian, a writer and occasional curator.

DAVID TOOP's first solo recordings were released on Brian Eno's Obscure label in 1975. His most recent album, *Black Chamber*, was released by Sub Rosa in 2003. He has written four books on music: *Rap Attack* (1984, 1991, 2000), *Ocean of Sound* (1995), *Exotica* (1999) and *Haunted Weather* (forthcoming). In 2000 he curated "Sonic Boom", the UK's most comprehensive exhibition of sound art to date, at the Hayward Gallery, London.

Photo credits: Stephen White, Hugo Glendinning, Peter Bellamy, Cav. I. Bessi, Christopher Burke, Beth Phillips, Fred Kihm, Adrian Hermanides

Acknowledgments

The artists — Jay Jopling, for having big, bright ideas and the generosity and will to do them — Annushka Shani, for her spirited and critical support — Susannah Hyman, for the expert, cool and friendly manner with which she kept me, the artists and the programme moving along — Honey Luard, for her subtle and exacting partnership on the book — Everyone who has not been singled out here but who is part of White Cube's dedicated team, has also been a joy to work with over these twelve quick months — Andreas Dornbracht, for his sophisticated sponsorship of this programme; — Stefanie Eckerskorn and Holger Struck, for their support and liason between sponsor and project — The technical team, Laurence Kavanagh, Marcus Mitchell, Paul Embleton, Adrian Hermanides and Emily Richardson, for their enthusiasm, good humour, and superb know-how — Hugo Glendinning and Steve White, for documenting the project series so generously in a tight space — Alice Rawsthorn, for her active and generous support of the programme throughout the year, both as colleague and friend — The writers.

The following individuals and organisations have actively assisted the ideas and needs of the programme, in order of appearance: Fuel; Molly Nesbit; Adrian Searle; Carmen Hammons, Sima Familant and Jeanne Greenberg Rohatyn (Artemis, Greenberg, Van Doren Gallery); Deniz Peckerman, Rosemarie Schwarzwälder; Yoshiko Isshiki; Takayuki Ishii and Ian Rosen (Taka Ishii Gallery); Michele Maccarone, Thomas Riegger and Jochen Meyer (Galerie Meyer Riegger);Jerry Gorovoy, Wendy Williams (Louise Bourgeois Studio), John Cheim and Howard Read, Lynn Tondrick (Cheim Read); Jutta Küpper; Rebecca Davis; Angèle Le Grand/Association Edna, Michael Morris (Cultural Industry/Artangel); Carla Chammas (CRG Gallery); Marina Warner; Brent Sikkema and Michael Jenkins (Brent Sikkema Gallery), Donald Young Gallery, Denise Neri; Paula Cooper, Steve Henry, Anthony Allen and Alissa Ruback (Paula Cooper Gallery); Natsuko Odate; David Byrne, he knows why — All the people (including my mother Anne Neri, who came all the way from the Antipodes) who showed up to a year of projects Inside the White Cube, in person and online.

Last but definitely not least, Mike Meiré and Florian Lambl of NEO NOTO, with whom, at the time of writing these acknowledgments, I was collaborating productively and happily on the concept, execution and tight schedule (!) of this lovely book.

Jay Jopling and Annushka Shani would like to thank Louise Neri, the artists, Andreas Dornbracht, Mike Meiré, Susannah Hyman and all the staff at White Cube.